Atlantic City 1854-1954
An Illustrated History

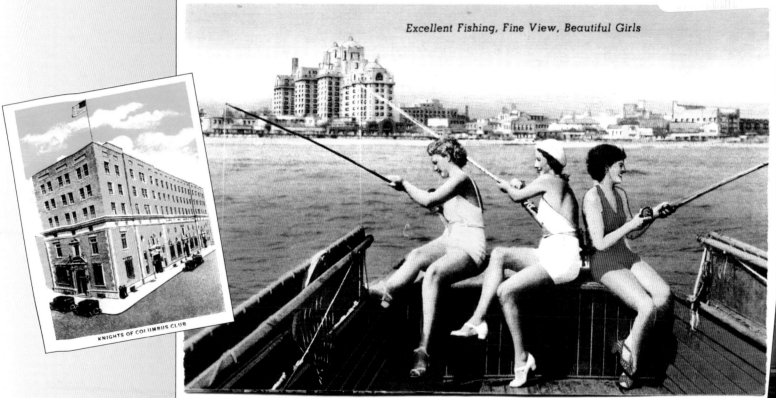

Excellent Fishing, Fine View, Beautiful Girls

KNIGHTS OF COLUMBUS CLUB

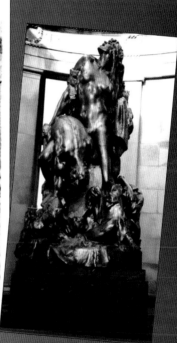

Fred and Susan Miller

Schiffer Publishing Ltd

4880 Lower Valley Road, Atglen, Pennsylvania 19310

Dedication

To our parents and grandparents who not only took us to the shore, but who shared their enthusiasm and joy for Atlantic City through their stories and pictures.

Acknowledgments

We would like to thank Stu Sirott for his technical know-how and hard work, Susan's sister and brother-in-law, Joan and Allan Okin, for their editing skills, Laura Currens, Hope Shaw, Mary Lois Hughes, and Sue Wright for the use of their postcards, and Phyllis Salins for the loan of pictures.

Other Schiffer Books on Related Subjects
Cape May Point, The Illustrated History, 0-7643-1830-6, $24.95
Greetings from Cape May, 978-0-7643-2678-3, $24.95
The Ocean City Boardwalk: Two-and-a-Half Miles of Summer, 0-7643-2455-1, $19.95

Copyright © 2009 by Fred and Susan Miller
Library of Congress Control Number: 2008942132

Designed by Mark David Bowyer
Type set in Eras Md BT / Souvenir Lt BT

ISBN: 978-0-7643-3187-9
Printed in China

Schiffer Books are available at special discounts for bulk purchases for sales promotions or premiums. Special editions, including personalized covers, corporate imprints, and excerpts can be created in large quantities for special needs. For more information contact the publisher:

Published by Schiffer Publishing Ltd.
4880 Lower Valley Road
Atglen, PA 19310
Phone: (610) 593-1777; Fax: (610) 593-2002
E-mail: Info@schifferbooks.com

For the largest selection of fine reference books on this and related subjects, please visit our web site at:
www.schifferbooks.com
We are always looking for people to write books on new and related subjects. If you have an idea for a book please contact us at the above address.

This book may be purchased from the publisher.
Include $5.00 for shipping.
Please try your bookstore first.
You may write for a free catalog.

In Europe, Schiffer books are distributed by
Bushwood Books
6 Marksbury Ave.
Kew Gardens
Surrey TW9 4JF England
Phone: 44 (0) 20 8392-8585; Fax: 44 (0) 20 8392-9876
E-mail: info@bushwoodbooks.co.uk
Website: www.bushwoodbooks.co.uk
Free postage in the U.K., Europe; air mail at cost.

Contents

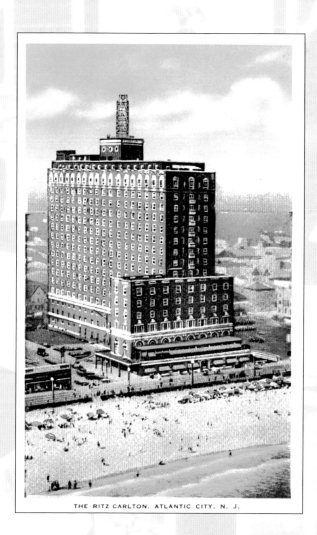

THE RITZ CARLTON, ATLANTIC CITY, N. J.

Introduction

The First 100 Years

Atlantic City is on Absecon Island, the southernmost barrier island in Atlantic County, New Jersey. Although it shares this island with Ventnor City, Margate City, and Longport, Atlantic City, at 11.92 square miles, is by far the largest community. It's also the oldest.

Absecon Island was known as far back as the early 1600s as Absegami by the Lenni-Lenape Indians, but it was not until the 1850s that any development took place. At that time, Jonathon Pitney, Richard Osborne, and Samual Richards formed a business partnership to build a railroad from Camden, New Jersey, near Philadelphia, Pennsylvania, so they could develop the island as a tourist destination.

Train service began in 1854 and hotels, large and small, were immediately built to accommodate the expected crowds. And come they did! By 1860, Atlantic City had a full-time population of seven hundred, and could lodge and feed as many as 4,000 summer visitors.

By 1870, the Boardwalk had been built, and by 1882, the first amusement pier over the ocean. More hotels were erected as quickly as possible to accommodate the growing summer crowds. Amusements, including theaters and dance halls as well as many restaurants, were soon part of the entertainment scene. Atlantic City quickly gained fame around the country, and the world, as "The World's Playground."

The year-round community grew and thrived as well. Schools were built, banks were started, newspapers were written, and churches and synagogues were dedicated. A library and a post office were built. The community was diverse; Christians of many denominations called Atlantic City home, as did many Jews. African-Americans, who had come from the south to work at construction jobs when the big hotels were being built, liked the city and remained.

The community found itself playing a large role in the war effort during World War II. Hotels were taken over for use as military hospitals and recuperative centers for servicemen. Atlantic City was dubbed "Camp Boardwalk" for the thousands of servicemen and women who trained, rested, and recovered from their wounds here.

Atlantic City was a place of many firsts: the rolling chair was invented here in 1884 by M. D. Shill, a Philadelphia manufacturer of invalid chairs. He opened a store to rent out baby carriages and wheelchairs to summer visitors. Within a few years, his invalid chairs had evolved into double chairs with a pusher and were used for sightseeing down the Boardwalk.

The picture postcard also got its start in Atlantic City. In 1895, the wife of resident Carl M. Voelker visited Germany, where she saw mailing cards, and returned to her husband with the idea. Voelker printed some in his print shop and sold them to beachfront hotels for advertisements. The idea quickly spread across the country. Atlantic City was the first city to use postcards for publicity.

Salt water taffy, of course, is synonymous with Atlantic City. In 1883, a storm tide drenched the Boardwalk taffy stand of David Bradley. When a child asked to buy some, Bradley joked, "You mean SALT WATER taffy!" The child was thrilled, word spread, and soon "salt water" taffy was being sold at every candy stand and store on the Boardwalk.

The first institution in the country dedicated to the convalescence of handicapped children, the Children's Seashore House, opened here in 1873.

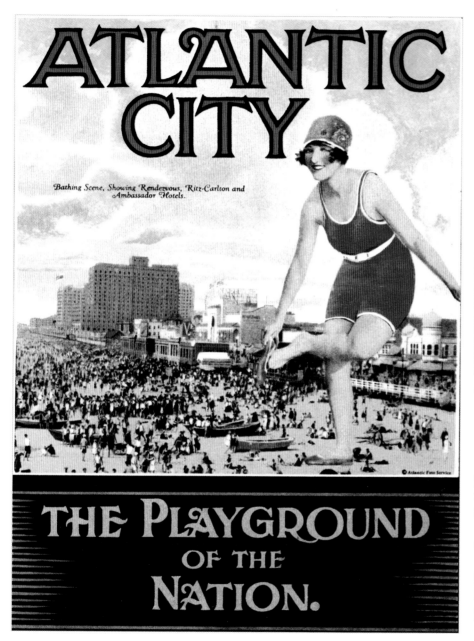

Atlantic City was long known as the "Playground of the Nation."

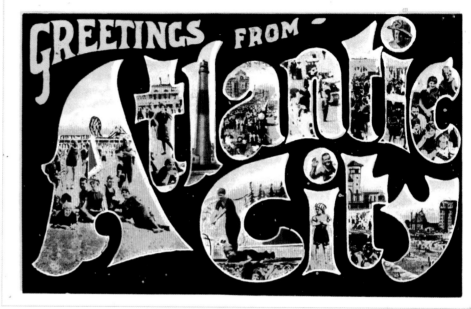

This "Greetings" postcard has scenes from the early 1900s.

In 1892, Atlantic City became the first municipality in the country to pay its lifeguards. In addition, it was the first to use the term "airport" when referring to its flying field, opened in 1919. The art of professional sand sculpting got its start here as well.

The Atlantic City Beauty Pageant, later called the Miss America Pageant, was first held in 1921.

Convention Hall, when it was built in 1929, was the largest building in the world constructed without roof posts or pillars. The first indoor collegiate football game was played there in 1930. Convention Hall had the largest pipe organ in the world as well as the largest stage.

Come share your memories, and ours, as you enjoy this book.

Chapter One
Transportation

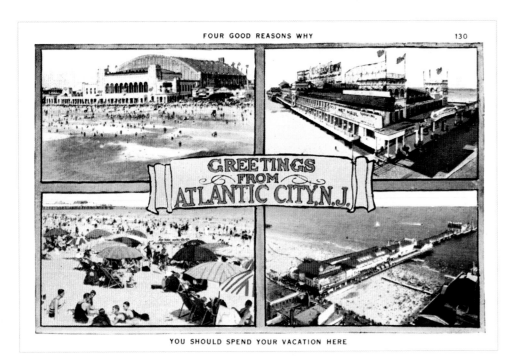

"Greetings from Atlantic City, You should Spend Your Vacation Here." There were many ways to get to Atlantic City, trains and planes in the beginning and later the automobile.

The word "airport" was coined in Atlantic City to designate its flying field, which opened in 1919 on the southwest side of Absecon Island on the inland waterway. Small commercial and private airplanes were able to use it.

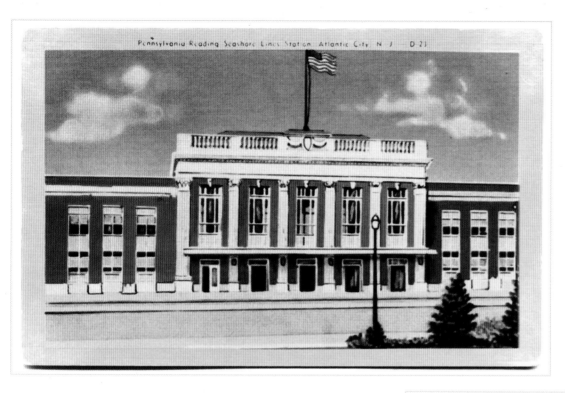

Pennsylvania Reading Seashore Lines Station Atlantic City, N. J. D-23

The first train line between Camden, New Jersey and Atlantic City was built in the 1850s, and trains continued to be the most common way to get to Atlantic City until the 1920s. This Pennsylvania-Reading Seashore Line Station was at Arkansas and Atlantic Avenues.

Before the construction of the New Jersey Turnpike and the Garden State Parkway, many people relied on trains to get to the Jersey Shore. The Central Railroad of New Jersey's "Blue Comet" was one of the most deluxe trains in the country. It made its inaugural run from Atlantic City to New York City on February 21, 1929.

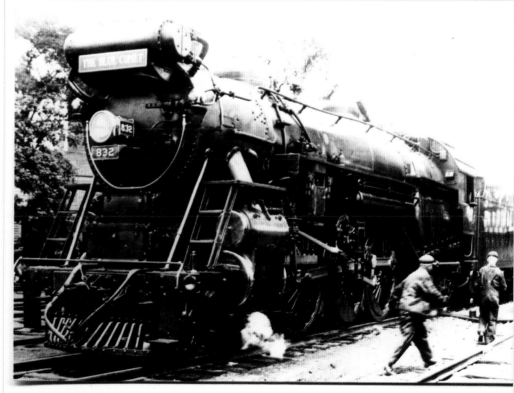

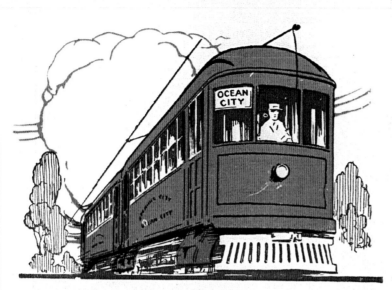

Complete Your Visit To The World's Playground
with a trip thru Green Pine Woods

►"SHORE FAST LINE"►

To Golf at	Northfield Linwood	Cars at **Virginia Avenue**
To the Charm of	Somers Point Ocean City	
To Airplane at	The Inlet	Cars on **Atlantic Avenue**
To Quaint	Longport	

Atlantic City & Shore R. R. Co.
Dial 5-3201

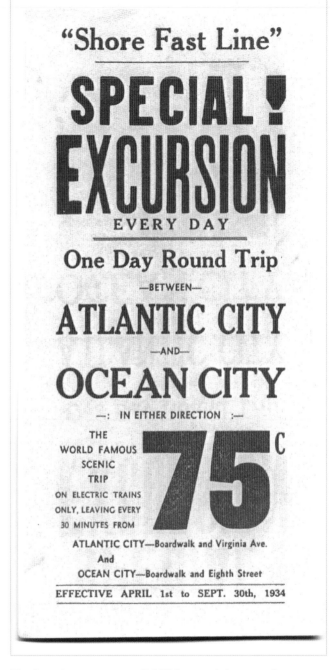

Starting in 1907, the Shore Fast Line, an electric train, ran between Atlantic City, Ocean City, and the mainland.

During the summer of 1934, special excursion rates were offered by the Shore Fast Line between Atlantic City and Ocean City.

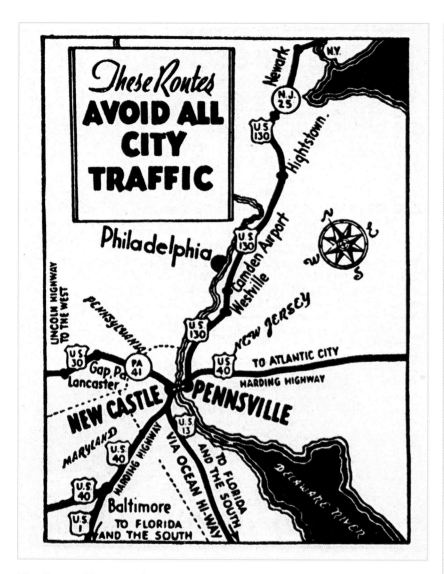

The Pennsville-New Castle Ferry took cars across the Delaware River between Delaware and New Jersey. By the late 1920s, the automobile was the favorite way to get to Atlantic City.

The Pennsville Ferry ran twenty-four hours a day during the summer.

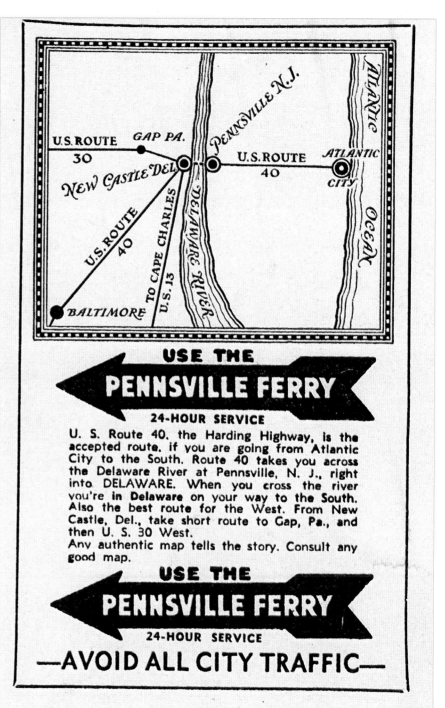

USE THE
PENNSVILLE FERRY
24-HOUR SERVICE

U. S. Route 40, the Harding Highway, is the accepted route, if you are going from Atlantic City to the South. Route 40 takes you across the Delaware River at Pennsville, N. J., right into DELAWARE. When you cross the river you're in Delaware on your way to the South. Also the best route for the West. From New Castle, Del., take short route to Gap, Pa., and then U. S. 30 West.

Any authentic map tells the story. Consult any good map.

USE THE
PENNSVILLE FERRY
24-HOUR SERVICE

—AVOID ALL CITY TRAFFIC—

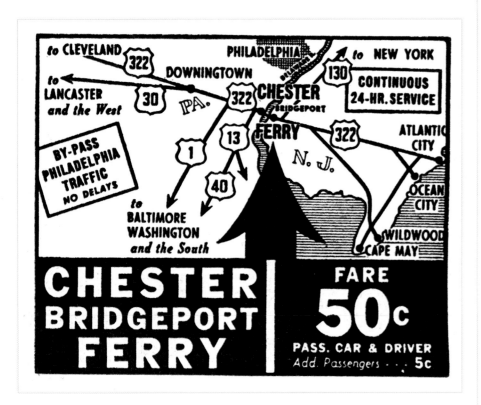

The Chester-Bridgeport Ferry allowed those coming from Washington, D.C. and Baltimore, Maryland to bypass the Philadelphia traffic.

AMERICAN OIL COMPANY
Products sold at progressive dealers and at the following American Oil service stations:

ATLANTIC CITY

Michigan & Pacific Aves.	Atlantic & Tennessee Aves.
Albany & Pacific Aves.	Maryland & Drexel Aves.
Bellevue & Atlantic Aves.	Albany & Winchester Aves.
Atlantic & Morris Aves.	Douglas & Ventnor Aves.

PLEASANTVILLE
Verona and Franklin Streets

During the early 1930s the American Oil Company advertised where its AMOCO gasoline was sold.

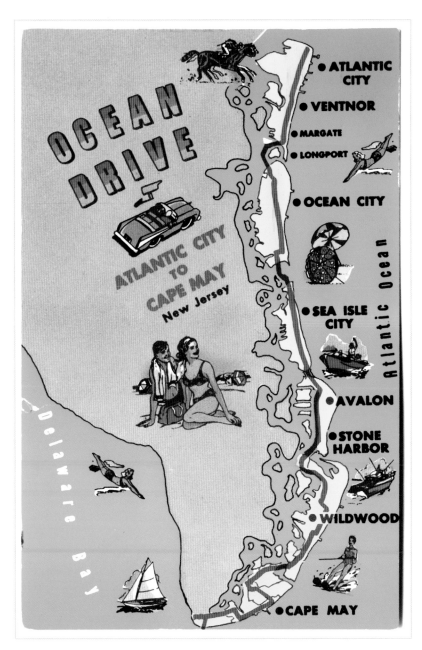

In 1940, the sixty-five mile long Ocean Drive opened. It connected all of the barrier islands from Atlantic City to Cape May Point.

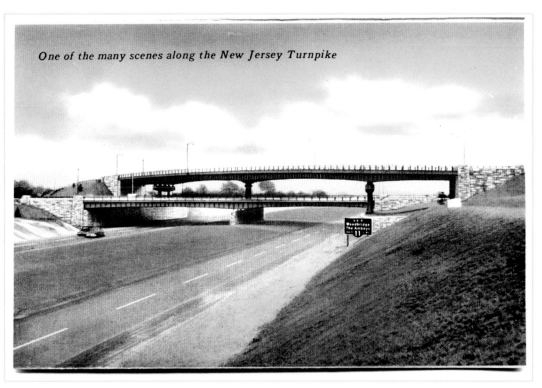

One of the many scenes along the New Jersey Turnpike

With more people driving cars, better roads were needed to get to the shore. The New Jersey Turnpike opened in November 1951. It was 118 miles long, had no stop lights or cross traffic, and a speed limit of sixty miles per hour. It was the beginning of the end for the trains.

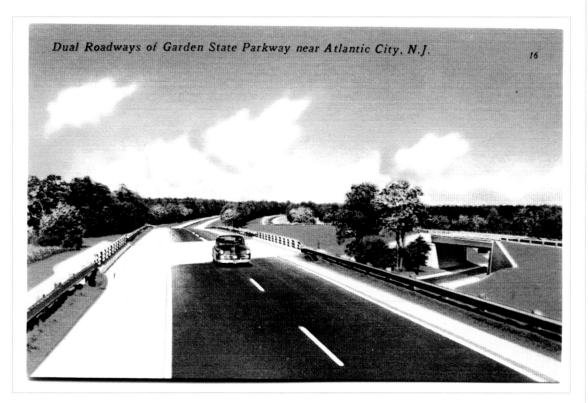

Dual Roadways of Garden State Parkway near Atlantic City, N.J. 16

The Garden State Parkway, opened in 1954, extends the length of New Jersey. While the New Jersey Turnpike is more on the western side of New Jersey, the Garden State Parkway runs along the coast, making the shore communities easily accessible.

Jitneys are a favored way to get around Atlantic City. The term "jitney" comes from the slang term for nickel, which was the fare on these vehicles when they began riding around Atlantic City in 1915.

Atlantic City Jitney Route Map

HISTORY OF THE JITNEY

The term jitney is an old English term and means nickel. Around the turn of the century many Jitney services sprang up throughout the country. The Atlantic City Jitney Association was started in 1915. It quickly became very successful and today ranks as the longest running non-subsidized transit company in America. In fact, there is an Atlantic City Jitney in the Smithsonian Institute.

The first Jitneys arrived on the streets in 1947. They were large black touring cars that used a rope and pulley system to open the back doors. The new Atlantic City Jitneys are a State-of-the-Art, air-conditioned, 13 passenger vehicle. Until recently, the standard Jitney colors were blue and white. Today they are a brilliant sky blue, complete with graphic design. All of the Jitneys are wheel chair equipped.

Chapter Two
Boardwalk and Convention Hall

This Atlantic City "Greetings" postcard shows the world famous Boardwalk and other attractions.

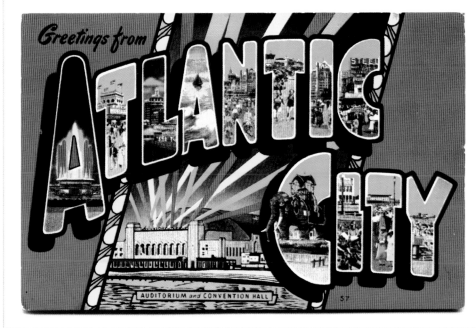

Atlantic City's Convention Hall is highlighted on this "Greetings" postcard.

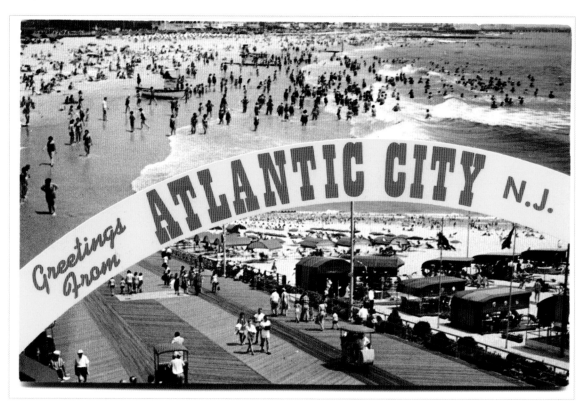

The Boardwalk is shown in this 1950s "Greetings from Atlantic City, N. J." postcard.

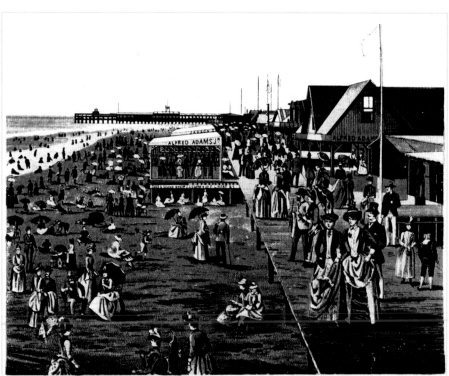

Atlantic City's Boardwalk, the first in the world, opened June 26, 1870. It was invented by Jacob Keim and Alexander Boardman to help keep sand out of the resort's hotels. The name "Boardwalk" was officially adopted as a street name by city ordinance dated August 17, 1896, and should therefore always be capitalized.

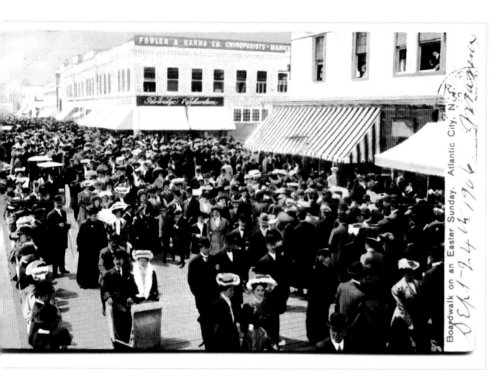

The first Easter Parade on the Boardwalk was held Sunday, April 16, 1876.

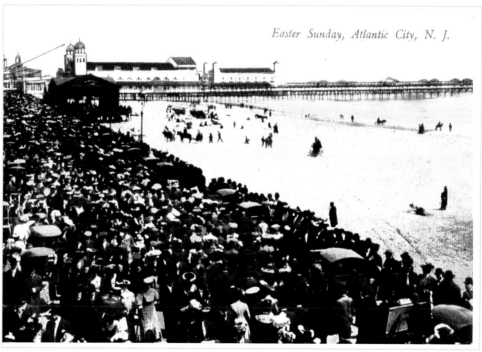

The Easter Sunday parade was always large, with everyone dressed in their Easter finery and out to stroll in the fair weather.

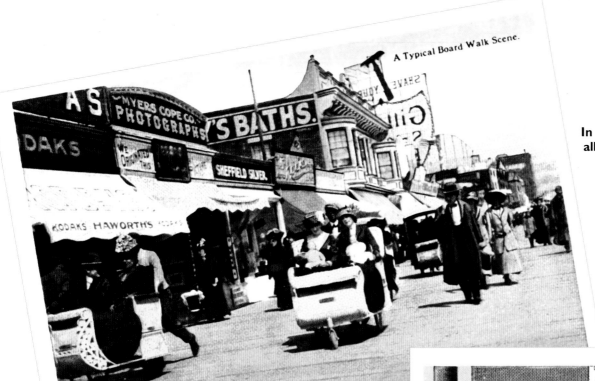

A Typical Board Walk Scene.

In 1914 rolling chairs were first allowed on the Boardwalk.

Rolling chair parades were another popular way to be seen on the Boardwalk.

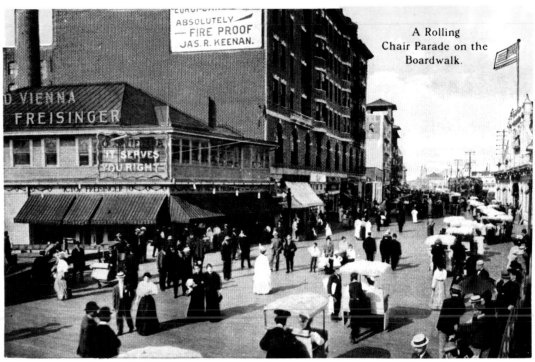

A Rolling Chair Parade on the Boardwalk.

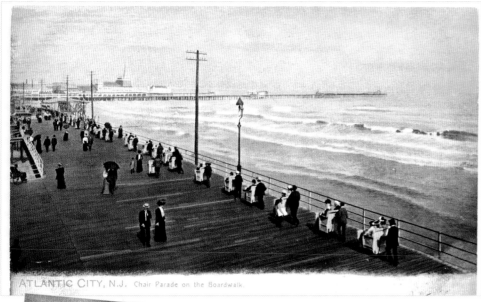

ATLANTIC CITY, N.J. Chair Parade on the Boardwalk.

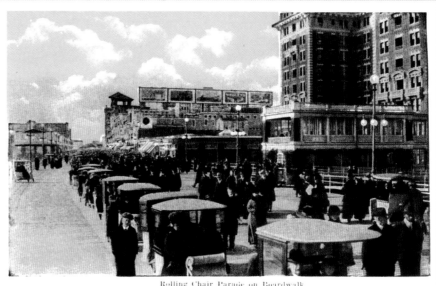

Rolling Chair Parade on Boardwalk.

Rolling chairs have been popular through the years. In some years, the rolling chairs had roofs to protect from the sun, as in this view.

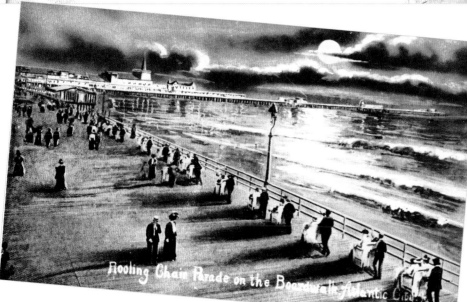

Rooling Chair Parade on the Boardwalk Atlantic City

Day and night-time views of this parade along the Boardwalk. Rolling Chair Parades on the Boardwalk were very popular images for postcards.

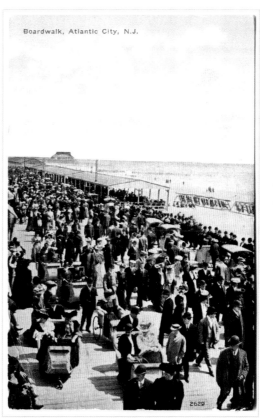

Boardwalk, Atlantic City, N.J.

This view of the Boardwalk shows some of the earlier rolling chairs.

17

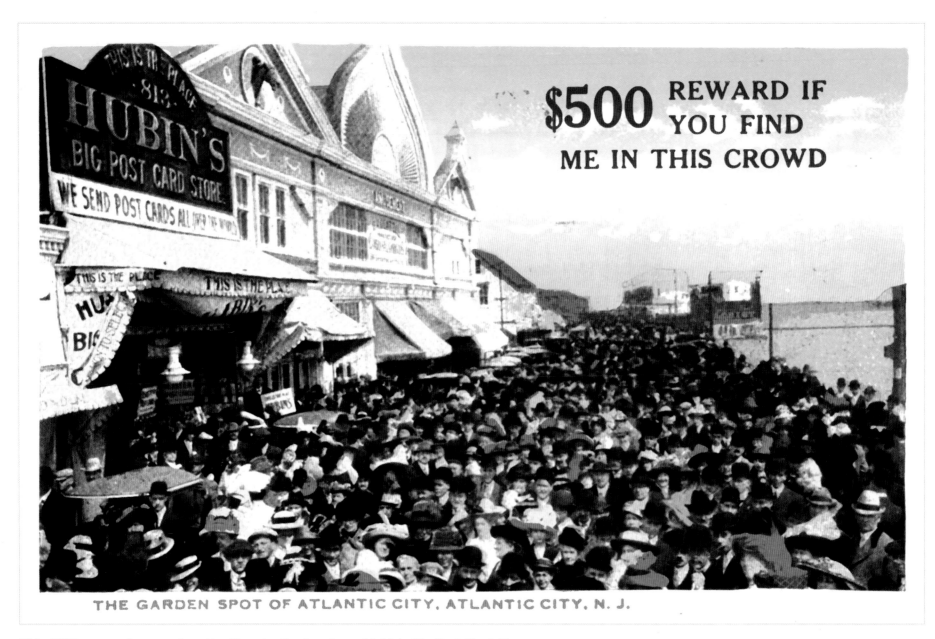

This 1917 scene of a crowd on the Boardwalk also shows Hubin's Big Post Card Store.
Atlantic City was the first resort to use postcards for publicity.

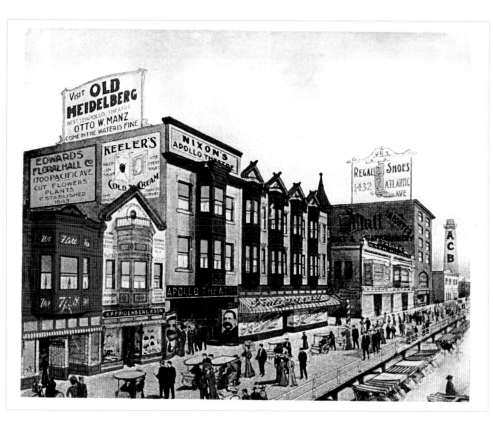

Nixon's Apollo Theatre was the first boardwalk theater. It opened April 17, 1908 at New York Avenue and the Boardwalk.

Fralinger's Salt Water Taffy advertised in the Apollo Theatre's program: "Between the Acts visit our Alcove in Lobby for Refreshing Drinks, Pure Candies and Choice Smoker's Requisites."

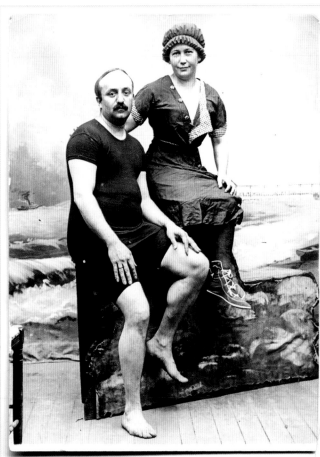

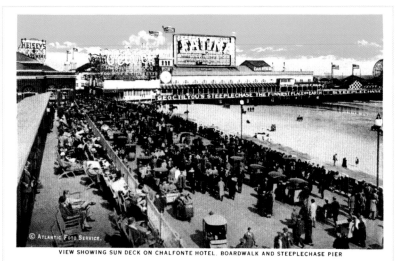

VIEW SHOWING SUN DECK ON CHALFONTE HOTEL, BOARDWALK AND STEEPLECHASE PIER

This view, taken from the deck of the Chalfonte Hotel, shows not only the crowd of strollers on the Boardwalk, but advertisement billboards on the top of the Steeplechase Pier.

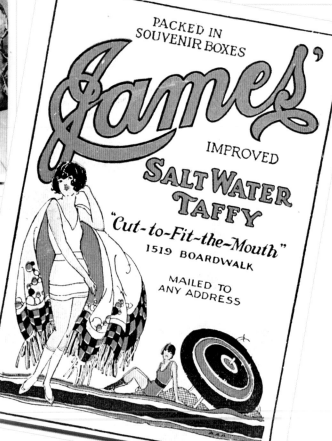

PACKED IN SOUVENIR BOXES

James'

IMPROVED SALT WATER TAFFY

"Cut-to-Fit-the-Mouth"

1519 BOARDWALK

MAILED TO ANY ADDRESS

Author Fred Miller's grandparents, Fred and Mary Miller, had their picture taken at one of the Boardwalk studios in 1912. In the early 1900s, it was custom — as well as city regulation — that bathing attire for women cover everything but the face and hands.

James' Salt Water Taffy was "cut-to-fit-the-mouth" and was sold from their store at 1519 Boardwalk.

This scene shows strollers in front of the Haddon Hall and Chalfonte Hotels.

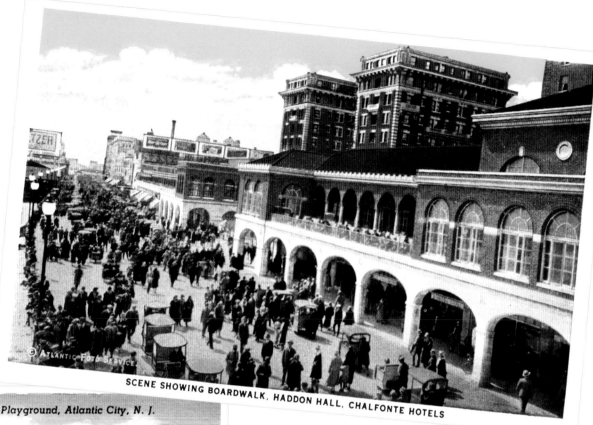

SCENE SHOWING BOARDWALK, HADDON HALL, CHALFONTE HOTELS

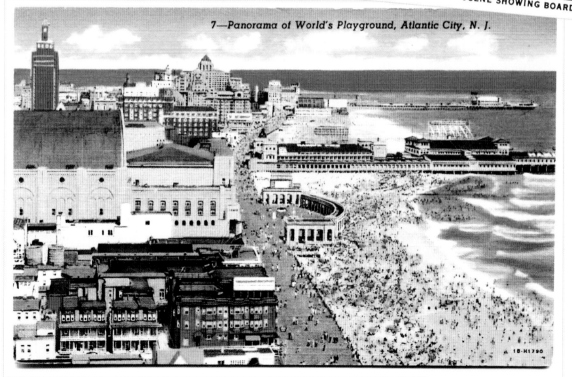

7—Panorama of World's Playground, Atlantic City, N. J.

This view of "The World's Playground" was taken in the 1920s.

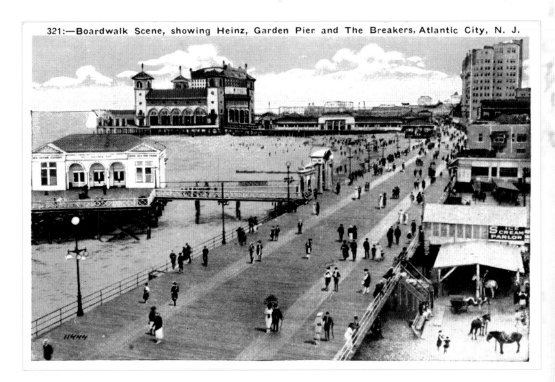

321:—Boardwalk Scene, showing Heinz, Garden Pier and The Breakers, Atlantic City, N. J.

A view of the Boardwalk showing the Breakers Hotel and Heinz and Garden Piers: saddled horses waiting for riders can be seen.

Some of the people in this view are enjoying a ride down the Boardwalk in rolling chairs while others stroll in front of the large hotels.

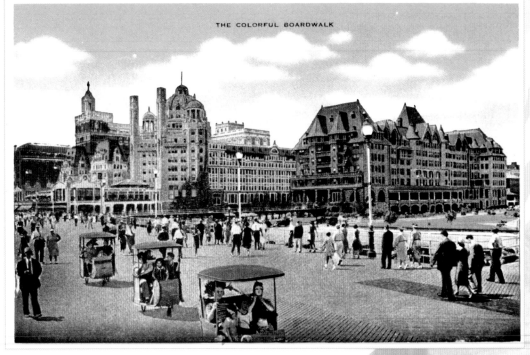

THE COLORFUL BOARDWALK

Many of the grand Boardwalk hotels could be seen from the deck of Central Pier, as illustrated in this postcard scene.

View from Sun Deck of Central Pier, Atlantic City, N. J.

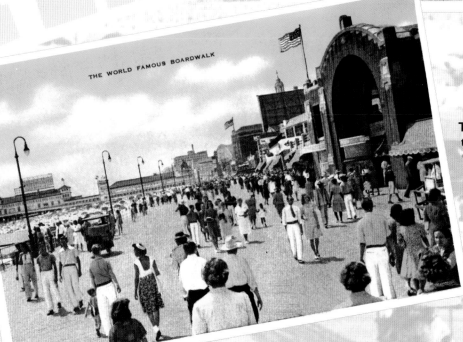

THE WORLD FAMOUS BOARDWALK

This scene of people walking on the Boardwalk could be the inspiration for the song, "On the Boardwalk in Atlantic City." The song was first heard in the 1946 movie, "Three Little Girls in Blue."

23

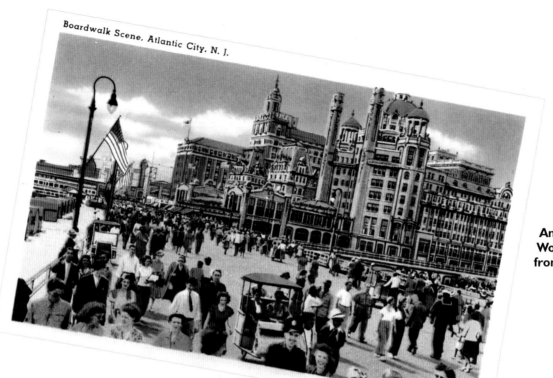

Boardwalk Scene. Atlantic City. N. J.

Another view of Atlantic City's World Famous Boardwalk, in front of large hotels.

This picture of author Susan Miller's Grandfather, Martin Isen, sister Joan Okin, center, and the author, right, was taken at one of the Boardwalk studios during the 1950s.

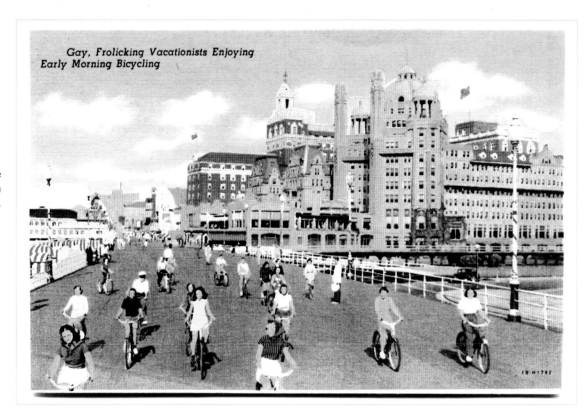

Crowds riding bicycles on the Boardwalk was a common sight most mornings.

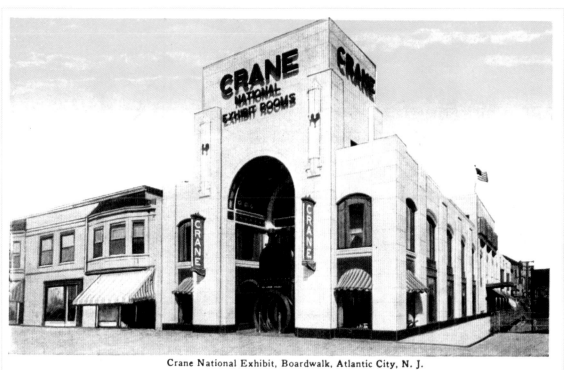

Crane National Exhibit, Boardwalk, Atlantic City, N. J.

In 1930, the Crane National Exhibit was on the Boardwalk at Georgia Avenue. It displayed the "newest and finest bathroom creations" and "the most modern and authentic conceptions of sanitation and heating equipment for the home."

25

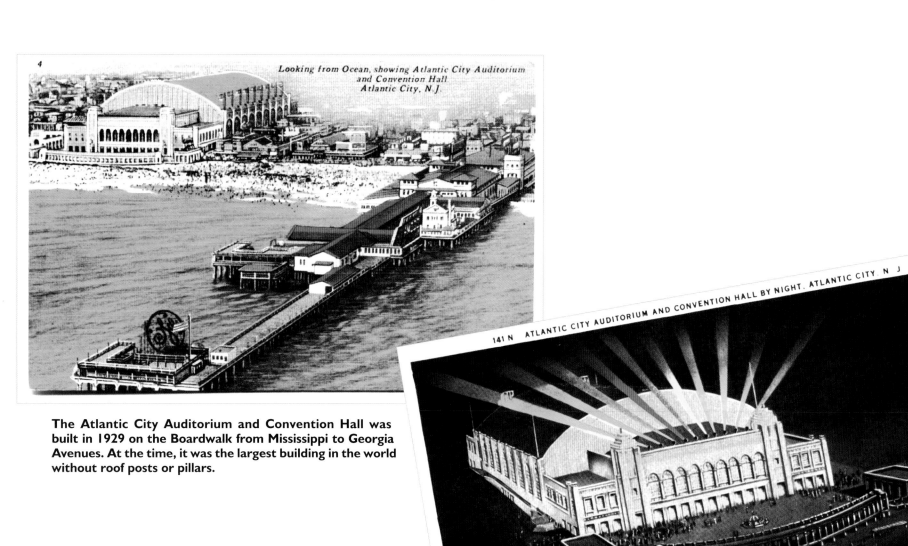

Looking from Ocean, showing Atlantic City Auditorium and Convention Hall Atlantic City, N.J.

141 N ATLANTIC CITY AUDITORIUM AND CONVENTION HALL BY NIGHT. ATLANTIC CITY. N J.

LARGEST CONVENTION HALL IN THE WORLD. SEATING CAPACITY. 40.000. BALL ROOM 5.000

The Atlantic City Auditorium and Convention Hall was built in 1929 on the Boardwalk from Mississippi to Georgia Avenues. At the time, it was the largest building in the world without roof posts or pillars.

Atlantic City's Convention Hall was the largest in the world and could seat 40,000 people. At night, bright lights shown from the roof.

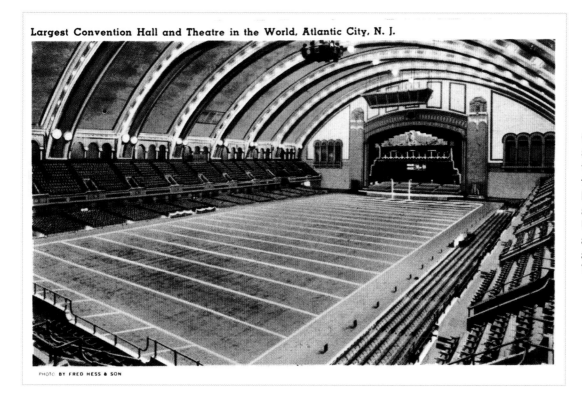

Largest Convention Hall and Theatre in the World, Atlantic City, N. J.

PHOTO BY FRED HESS & SON

Convention Hall covered seven acres. On October 25, 1930, the nation's first indoor college football game was played there between Lafayette College and Washington and Jefferson University with 25,000 people attending the game. Washington and Jefferson University won, 7-0.

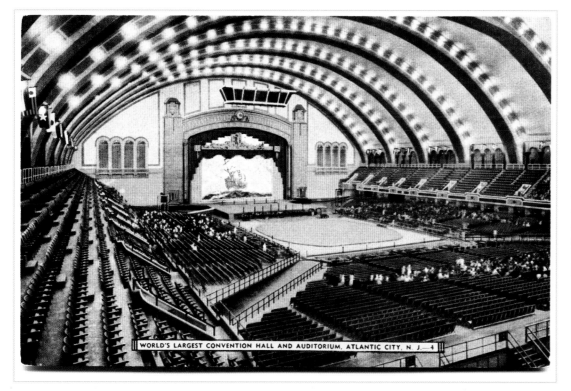

WORLD'S LARGEST CONVENTION HALL AND AUDITORIUM, ATLANTIC CITY, N. J.—4

Convention Hall had the largest pipe organ in the world. It contained 32,913 pipes. The organ was designed by Emerson L. Richards and built by the Midmer-Losh Company.

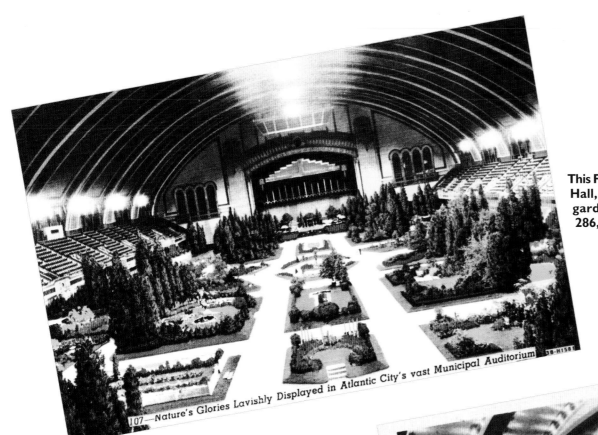

107—Nature's Glories Lavishly Displayed in Atlantic City's vast Municipal Auditorium 5B-H1581

This Flower Show, held at Convention Hall, included a complete sunken garden. The exhibition area was 286,000 square feet.

Convention Hall had the largest stage in the world. The exhibition area was so large that ice skating carnivals, horse shows, and other events were held there as well. The basement could park 1,000 cars.

LARGEST CONVENTION HALL AND THEATRE IN THE WORLD, ATLANTIC CITY, N. J.

The Convention Hall Ballroom was off the main auditorium. It was 181 feet long, 128 feet wide, and 75 feet high. The room could seat 3,000 people and was used for concerts and other events including dance parties.

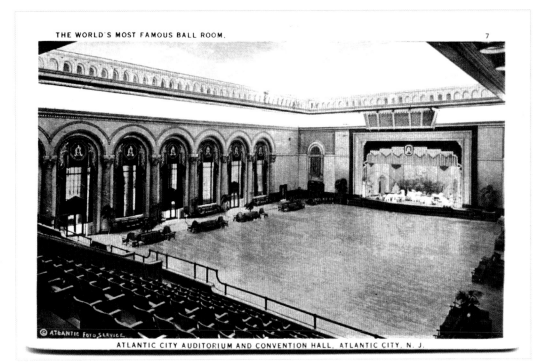

ATLANTIC CITY AUDITORIUM AND CONVENTION HALL, ATLANTIC CITY, N. J.

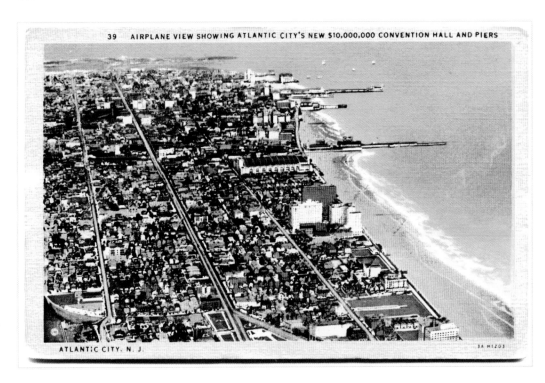

39　AIRPLANE VIEW SHOWING ATLANTIC CITY'S NEW $10,000,000 CONVENTION HALL AND PIERS

ATLANTIC CITY, N. J.

This aerial view shows Atlantic City, the beach, Boardwalk piers, and the new $10,000,000 Convention Hall.

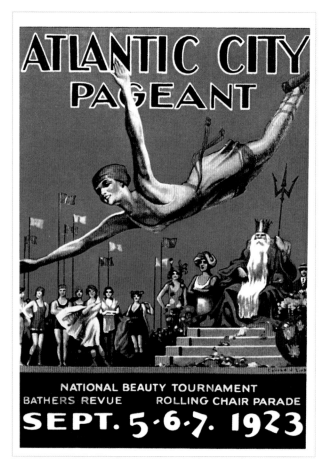

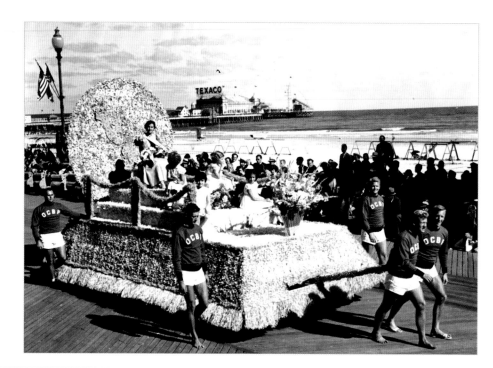

The Miss America Pageant week always included a parade down the Boardwalk with an Ocean City float pulled by members of the Ocean City Beach Patrol.

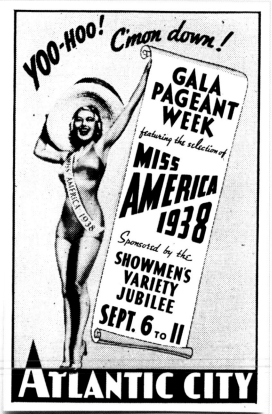

The Atlantic City Beauty Pageant was first held on September 6-7, 1921 on Steel Pier. There were eight contestants. Reverend James E. Lake, head of neighboring Ocean City's Camp Meeting Association, was against the pageant. He wrote, "The danger comes in taking girls of tender years and robing them in attire that transgresses the limit of morality. The effect on them and the publication of their photographs in the newspapers are to be highly deplored." However, little notice was taken of his words; by 1923, there were seventy-five contestants in the pageant!

By 1938, the beauty pageant had been renamed the Miss America Pageant, and the festivities lasted an entire week.

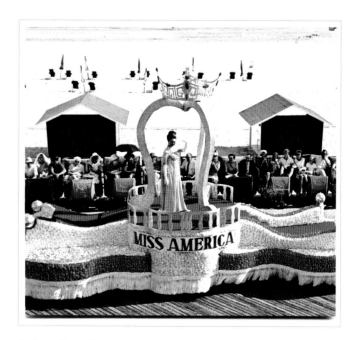

A favorite place to watch the Miss America Parade was from the Boardwalk rolling chairs.

1955

Miss America
PAGEANT

TALENT and BEAUTY CONTEST
SEPT. 7, 8, 9, 10 − − 8:30 P.M.
ATLANTIC CITY AUDITORIUM

50 Lovely Ladies from 47 States, Hawaii, Puerto Rico and Canada

GALA STAGE SHOW PRODUCED BY **VINTON FREEDLY**	**BERT PARKS** Master of Ceremonies

with

Miss Florida 1955 Miss Ohio 1955
Miss District of Columbia 1955

featuring

GORDON MacRAE Singing Star of Television, Stage and Radio WEDNESDAY NIGHT, SEPT. 7	**WALTER CASSEL** Metropolitan Opera Star FRIDAY NIGHT, SEPT. 9

Tickets: Wednesday, Thursday, Friday — $1.00 to $3.00
Saturday Night — $2.00 to $7.50

**BOARDWALK ILLUMINATED NIGHT PARADE
TUESDAY, SEPTEMBER 6th**
PHONE AUDITORIUM BOX OFFICE 4-3081

The 1955 Miss America Pageant was the first one in which Bert Parks acted as Master of Ceremonies.

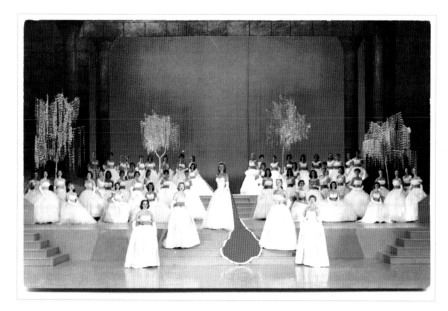

The Miss America Pageant grew in size and attraction after it moved from Steel Pier into Convention Hall in 1940.

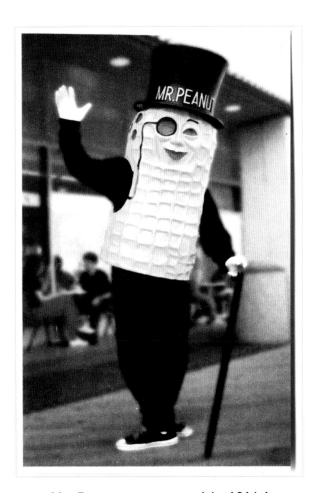

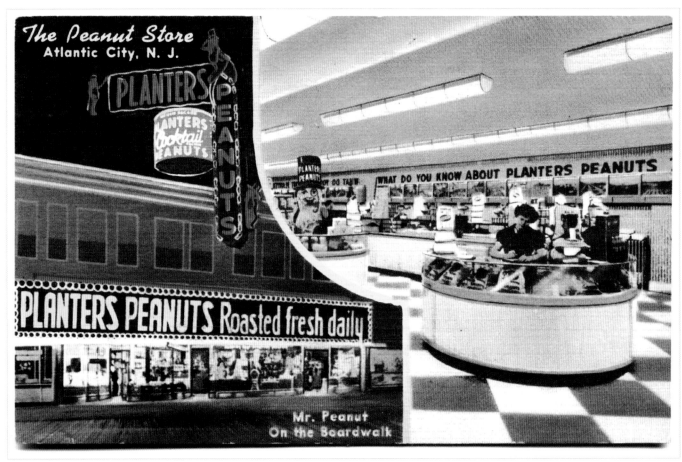

Mr. Peanut was created in 1916 by Antonio Gentile, a fourteen-year-old from Suffolk, Virginia who won a contest to design a symbol for Planters Peanuts. Mr. Peanut's top hat, monocle, and cane were added by the company.

Planters Peanuts opened a store on the Atlantic City Boardwalk in the 1930s. Planters' Mr. Peanut became an unofficial ambassador for Atlantic City.

Chapter Three
Beaches and Lifesavers

This view of Atlantic City's beach was one of the most popular, with the famous hotels in the background.

From the back: "Always fascinating, the ocean with its restless, continuous roll, is indeed a fairy scene under the silver rays of the moon. A thing of beauty one never tires of watching and listening to the ebb and flow of the tide."

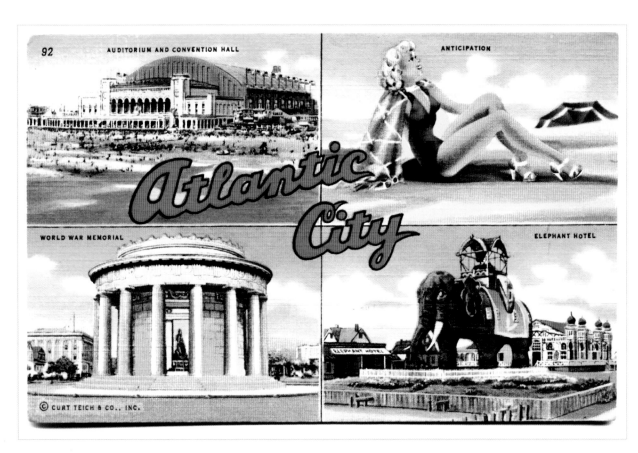

This 'Greetings' postcard shows four famous images of Atlantic City!

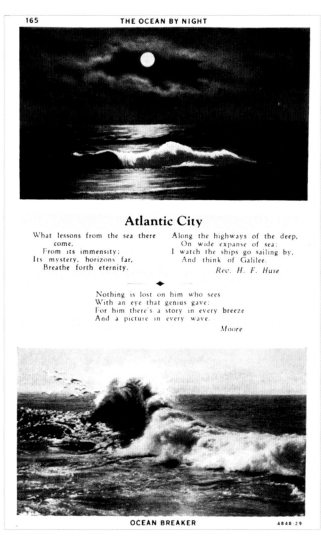

Views of the ocean in Atlantic City—these poems say it all!

This early view of many bathers in the ocean and on the beach also shows the St. Charles and Rudolf Hotels and Heinz Pier.

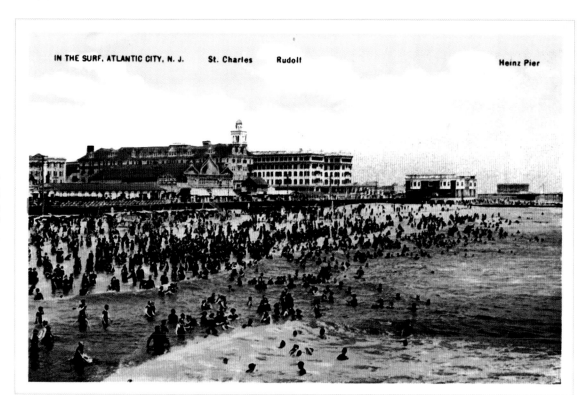

IN THE SURF. ATLANTIC CITY, N. J. St. Charles Rudolf Heinz Pier

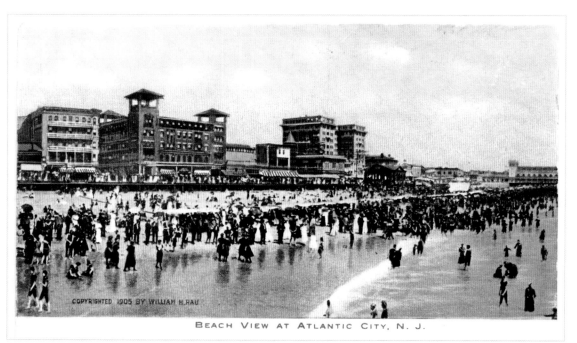

COPYRIGHTED 1905 BY WILLIAM H. RAU

BEACH VIEW AT ATLANTIC CITY, N. J.

This postcard, copyrighted 1905, shows many beach-goers. The women were attired from head to toe, even those bathing in the ocean. The men's swimsuits were made of wool.

35

BEACH AND BOARD WALK, ATLANTIC CITY, N. J.

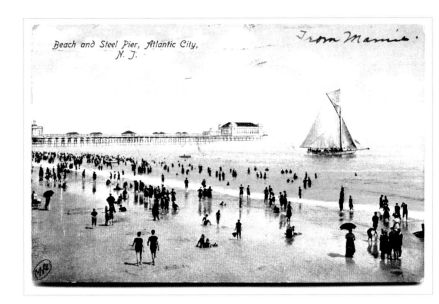

Beach and Steel Pier, Atlantic City, N. J.

From Mamie

This early scene of the beach shows the boardwalk hotels in the background.

This large sailboat seems to have caught the attention of many of the beach-goers.

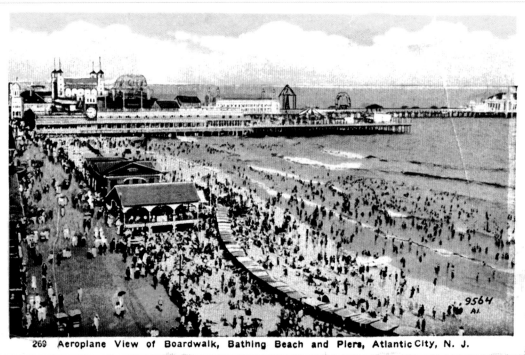

9564
A1.

269 Aeroplane View of Boardwalk, Bathing Beach and Piers, Atlantic City, N. J.

**An aerial view of the beach: a line of cabanas can be seen.
The cabanas were used to shelter people from the sun.**

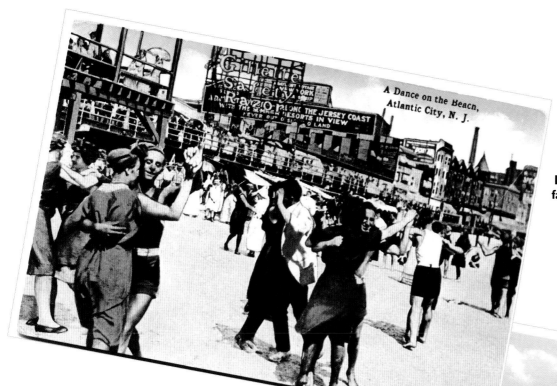

A Dance on the Beach,
Atlantic City, N. J.

Dancing on the beach was a
favorite past time in 1915.

This early beach scene is in
front of the Traymore Hotel.

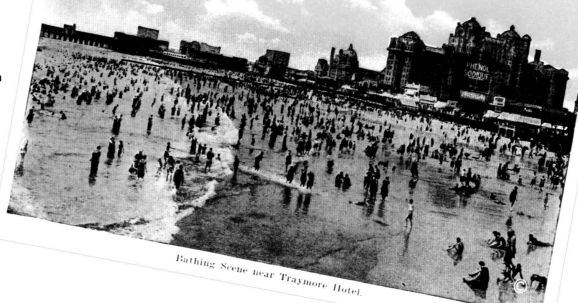

Bathing Scene near Traymore Hotel.

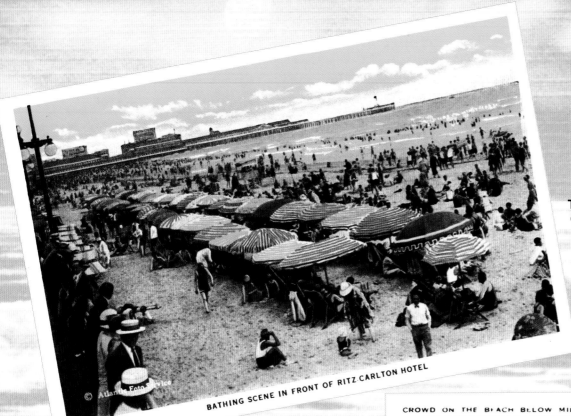

BATHING SCENE IN FRONT OF RITZ-CARLTON HOTEL

This mid-1920s view in front of the Ritz-Carlton Hotel shows large umbrellas being used to ward off the sun.

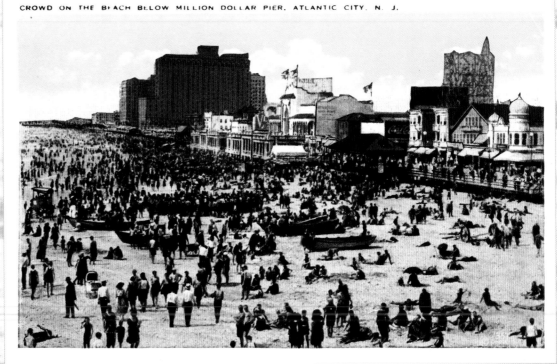

CROWD ON THE BEACH BELOW MILLION DOLLAR PIER, ATLANTIC CITY, N. J.

There are many lifeguard boats on this crowded beach below the Million Dollar Pier.

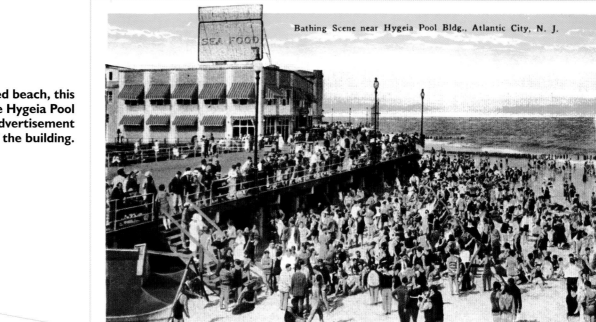

Bathing Scene near Hygeia Pool Bldg., Atlantic City, N. J.

Another crowded beach, this one in front of the Hygeia Pool Building. Note the advertisement sign on top of the building.

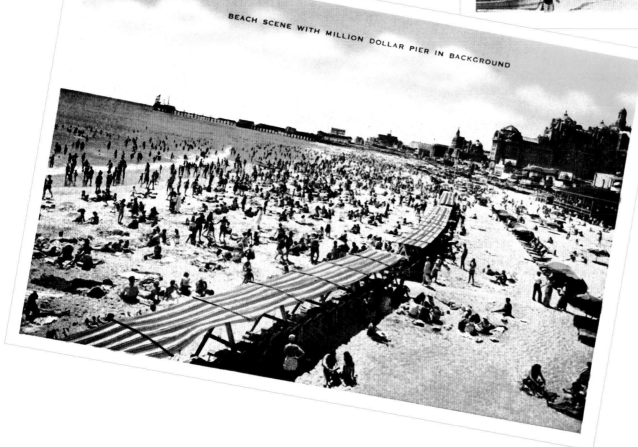

BEACH SCENE WITH MILLION DOLLAR PIER IN BACKGROUND

Many of the beach-goers in this view are using the cabanas and chairs to relax—*out* of the sun.

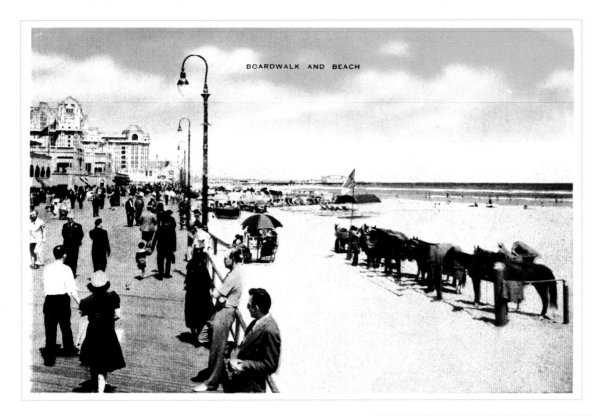

The people walking on the Boardwalk in this scene do not seem to be taking any notice of the horses standing on the beach.

Pony riding on the beach was always fun!

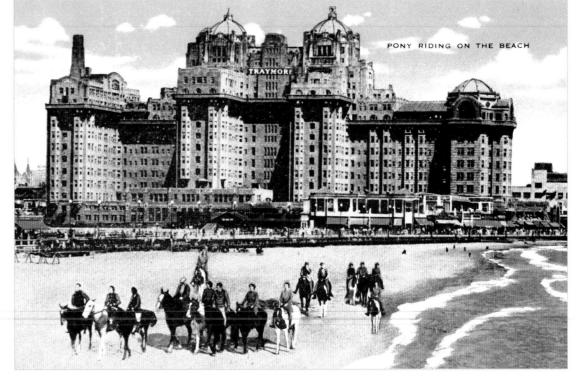

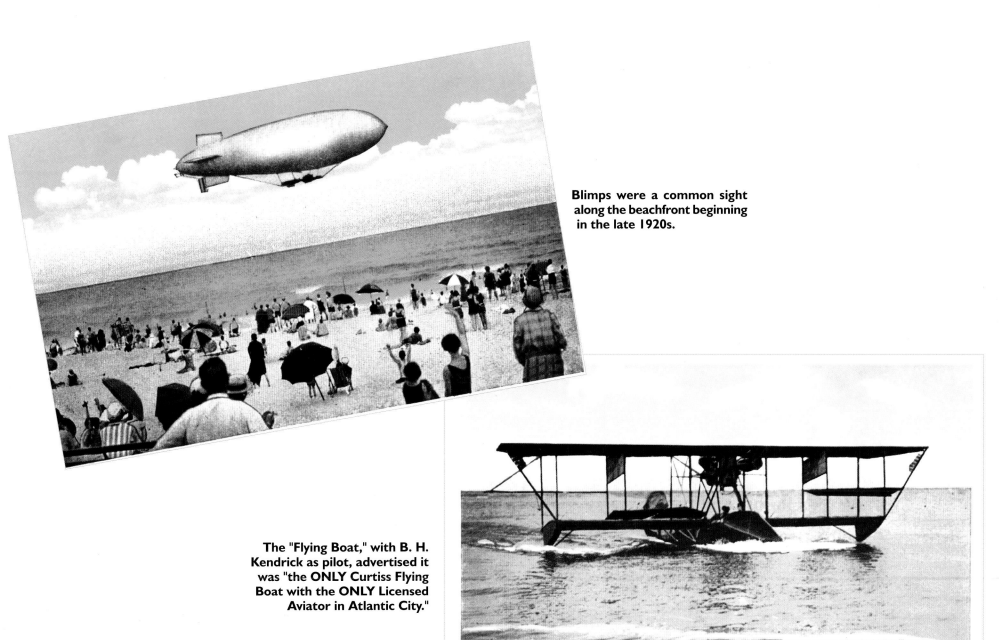

Blimps were a common sight along the beachfront beginning in the late 1920s.

The "Flying Boat," with B. H. Kendrick as pilot, advertised it was "the ONLY Curtiss Flying Boat with the ONLY Licensed Aviator in Atlantic City."

104 Hydroaeroplane gliding along the Beach front, Atlantic City, N. J.

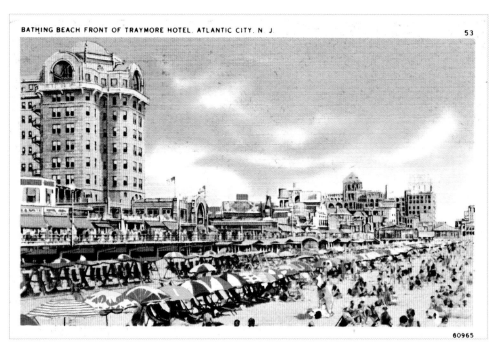

BATHING BEACH FRONT OF TRAYMORE HOTEL, ATLANTIC CITY, N. J. 53

60965

Another busy beach scene with rows of cabanas and beach umbrellas.

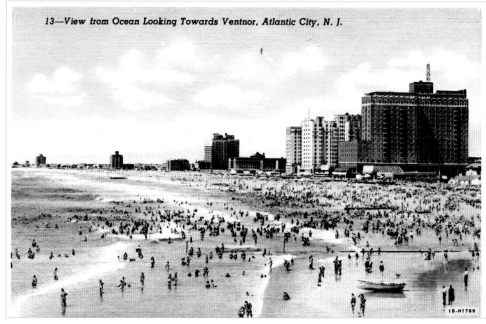

13—View from Ocean Looking Towards Ventnor, Atlantic City, N. J.

1B-H1789

From the back: "Atlantic City is a city of fine hotels, boarding houses and apartments. The ocean-front skyline presents the world's most magnificent hotel architecture."

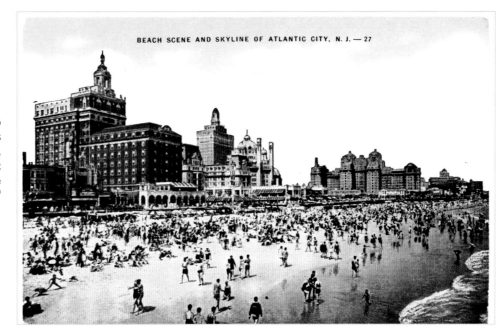

From the back: "Familiar to thousands of moviegoers is this colorful beachfront scene, which symbolizes Atlantic City's pre-eminence as the 'World's Playground.'"

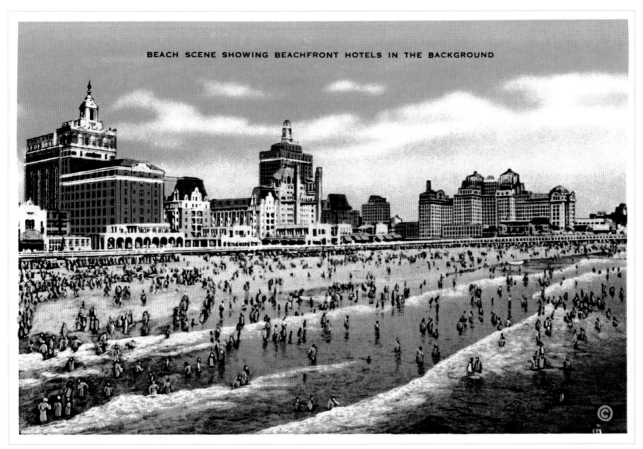

The beachfront showing the beachfront hotels was a favorite postcard scene.

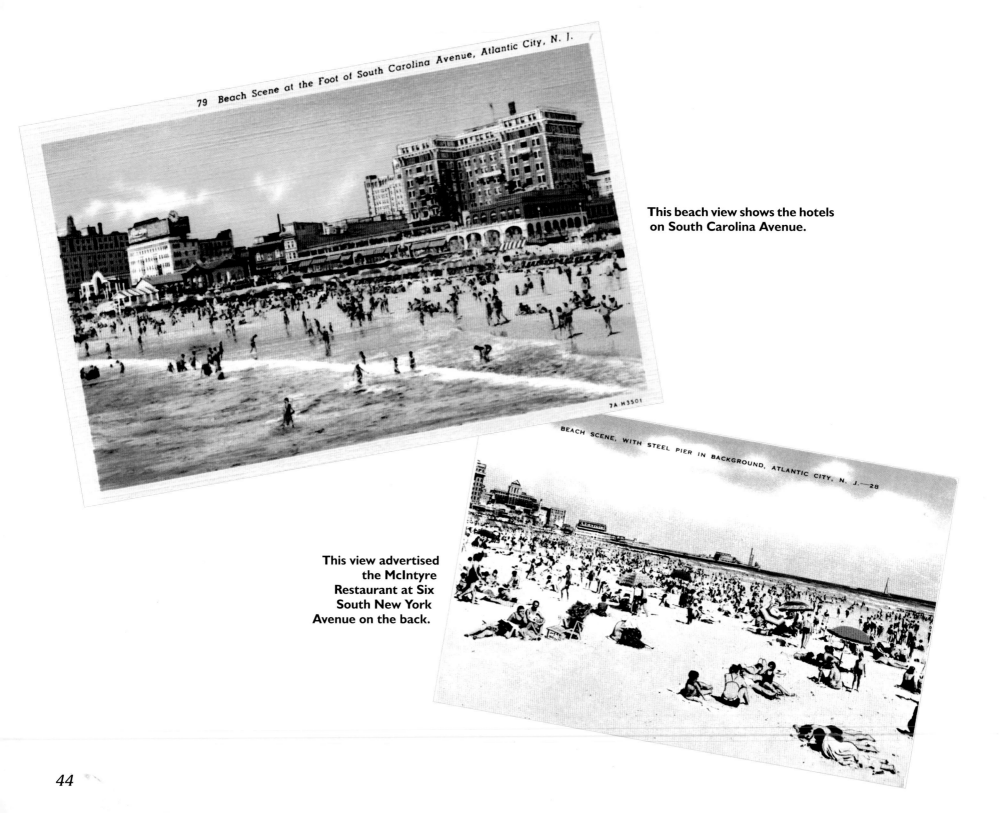

79 Beach Scene at the Foot of South Carolina Avenue, Atlantic City, N. J.

7A H3501

This beach view shows the hotels on South Carolina Avenue.

BEACH SCENE, WITH STEEL PIER IN BACKGROUND, ATLANTIC CITY, N. J.—28

This view advertised the McIntyre Restaurant at Six South New York Avenue on the back.

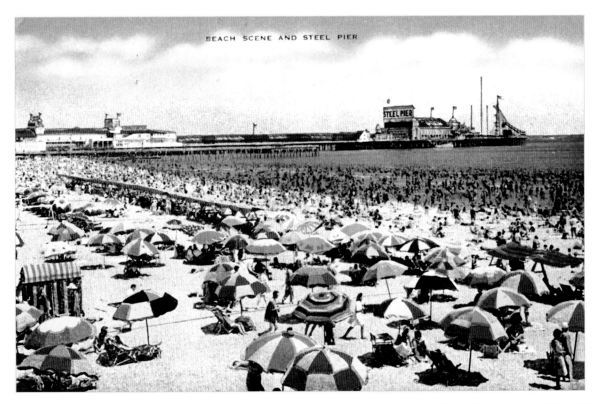

BEACH SCENE AND STEEL PIER

From the back: "The Atlantic City Beach is the most perfect to be found on the Atlantic Ocean. It is so flat and shelves so gradually that there is little danger from holes or cross currents. Millions have found the way to happiness and health on its sands."

This scene shows the famous flower gardens on the beach and cabana rooms. From the back: "Where dining and other leisure activities can take place out of the sun, but still enjoying the salt air."

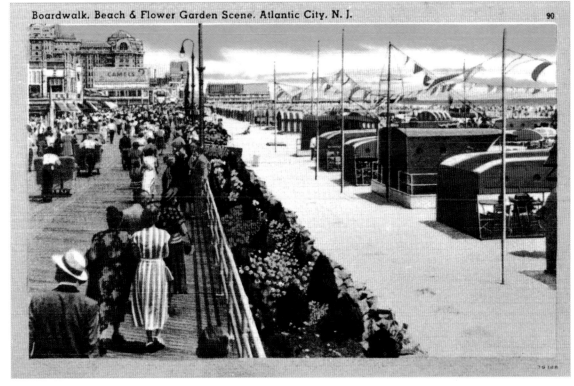

Boardwalk, Beach & Flower Garden Scene. Atlantic City, N. J. 90

During the early days of beach-going, bathers, especially women, covered up. No one knew the benefits of sunbathing and no one wanted to get tan.

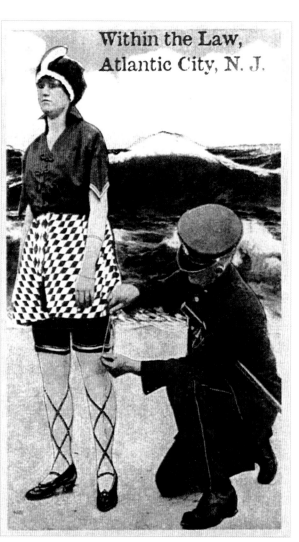

A city ordinance kept bathers from baring too much. During the early 1920s, Atlantic City employed "censors" to check that not too much skin was showing. Men also had to cover up. Not until the 1940s were men allowed to bare their chests.

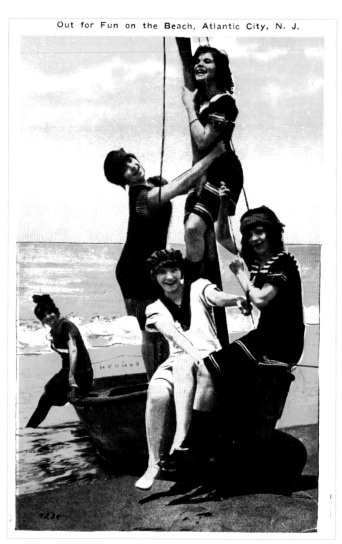

These women made sure to keep covered enough while still having fun on the beach.

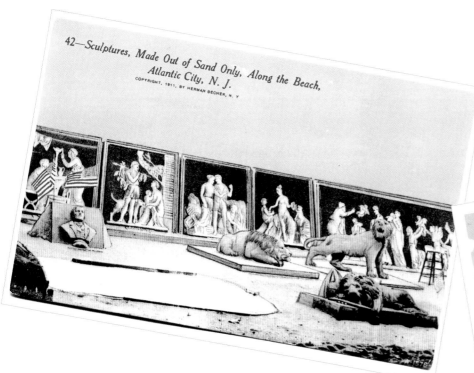

42—Sculptures, Made Out of Sand Only, Along the Beach, Atlantic City, N.J.
COPYRIGHT, 1911, BY HERMAN BECHER, N.Y.

In 1897, the art of professional sand sculpting began on the Atlantic City beach. Talented sculptors created memorable scenes that lasted until the next storm washed them away.

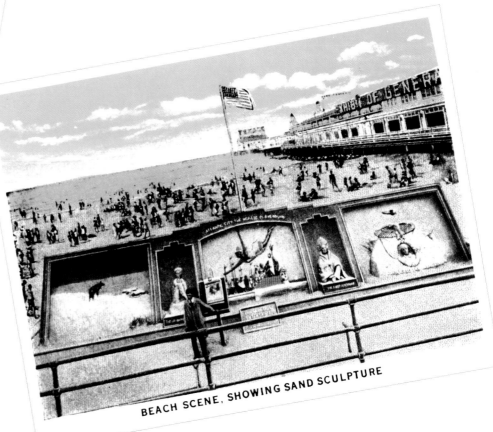

BEACH SCENE, SHOWING SAND SCULPTURE

From the back: "A unique novelty is offered to tourists on the strand of Atlantic City in the artistic creations of the Sand Artists. There are generally three or four gifted young sculptors along the beach just over the edge of the Boardwalk where pedestrians may look down upon their work."

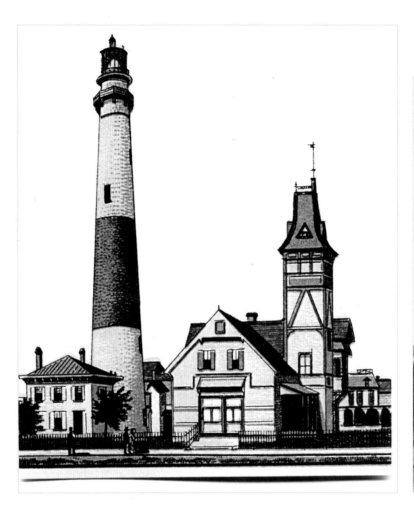

This Life-Saving Station was built in 1884 next to the lighthouse at Pacific and Vermont Avenues. It was one of the finest life-saving stations on the coast.

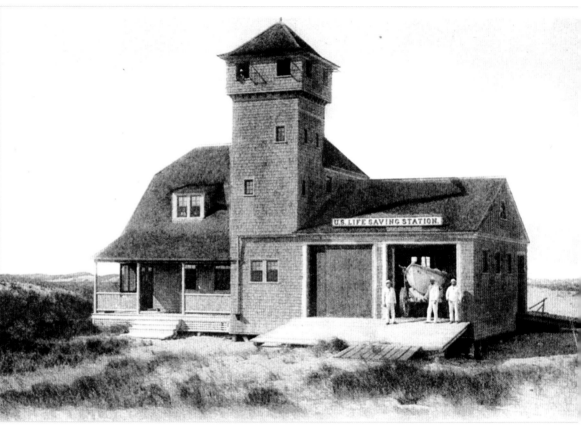

This Life-Saving Station was built in 1896, about three miles south of the lighthouse, on Annapolis Avenue near Atlantic Avenue.

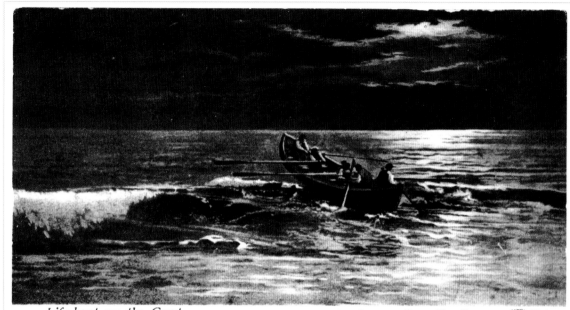

Life-boat on the Crest. *At Atlantic City, N. J.* 71-4

The lifeboat was the most valuable piece of equipment to the men of the **Life-Saving Service.**

After the lifeboat, the breeches buoy was the next most valuable piece of equipment.

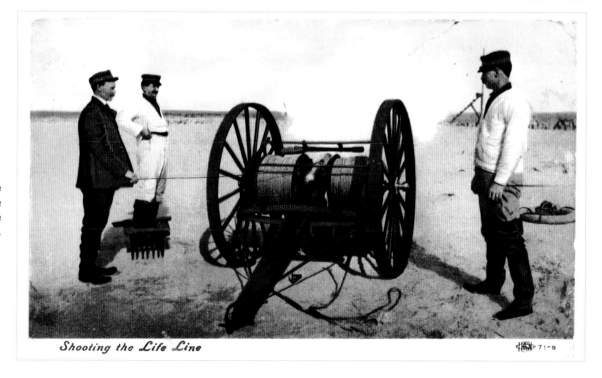

Shooting the Life Line 71-9

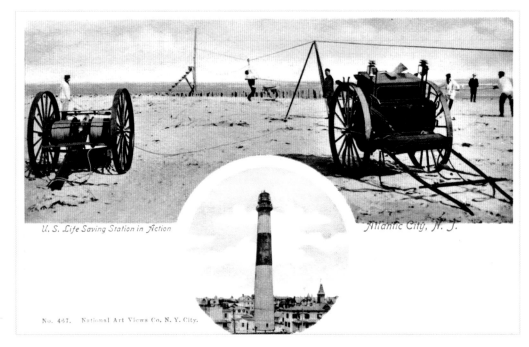

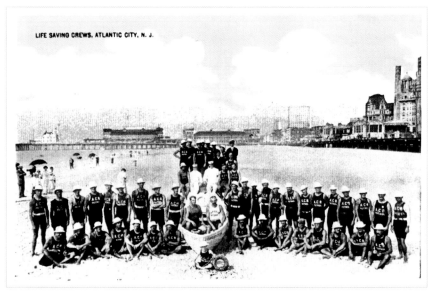

This scene shows a breeches buoy in action during a drill by the men of the Life-Saving Service.

Every year, the lifeguards pose for a group picture. They are rightly proud of the work they do.

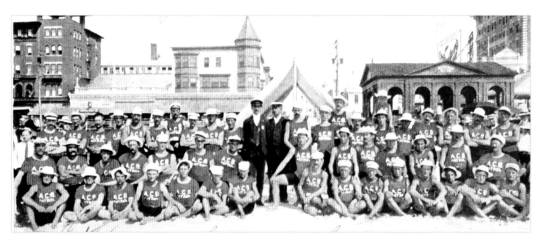

In 1892 Atlantic City became the first municipality in the country to pay for bather protection. The patrol started out with only a few men, but by 1905 had grown to this size (shown on this postcard) because of need.

In 1904, Dr. John T. Beckwith was appointed by the City Council to serve as beach surgeon. He organized medical service right on the beach. Tents were set up on the sand to serve as first aid stations.

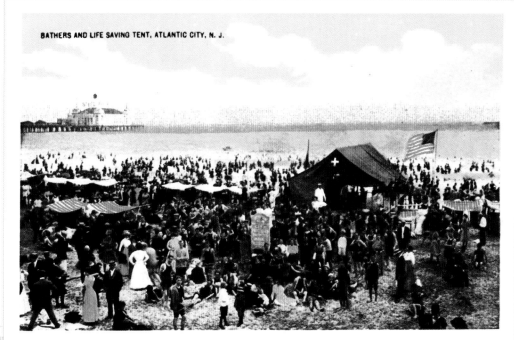

BATHERS AND LIFE SAVING TENT, ATLANTIC CITY, N. J.

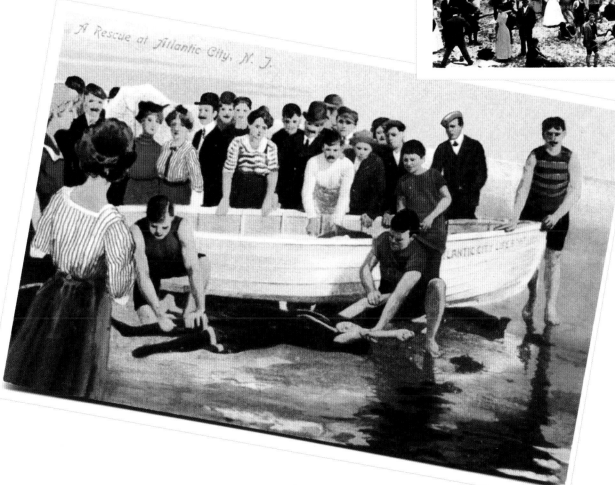

A Rescue at Atlantic City, N. J.

These lifeguards are trying to revive a woman using the original Schaefer Method of Resuscitation after they rescued her from the ocean.

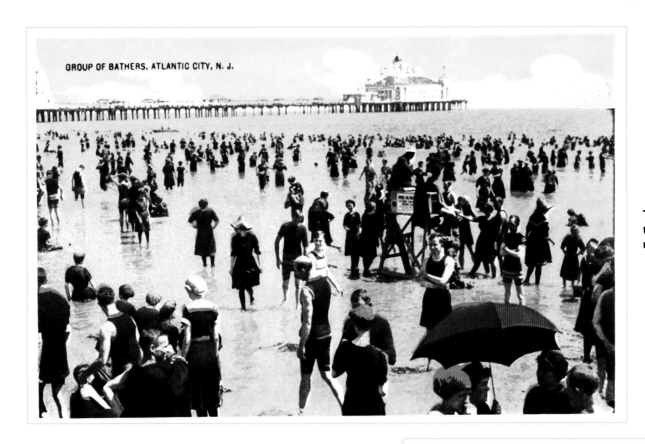

GROUP OF BATHERS, ATLANTIC CITY, N. J.

The lifeguards kept watch over the bathers from their stands set up on the beach.

The lifeboat was a valuable piece of lifesaving equipment for the Atlantic City Beach Patrol, which traced its roots to the United States Life-Saving Service.

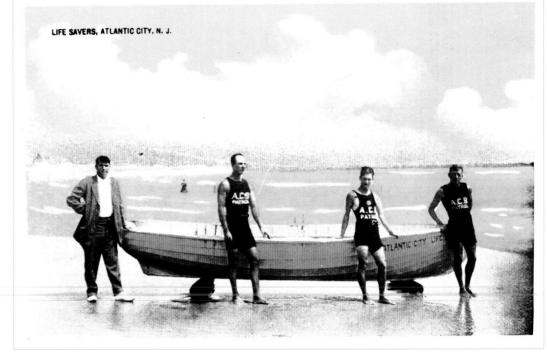

LIFE SAVERS, ATLANTIC CITY, N. J.

From the back: "Atlantic City's Bathing Beach is famous for its safety, made so naturally, and kept that way by the finest Beach Patrol organization in the world."

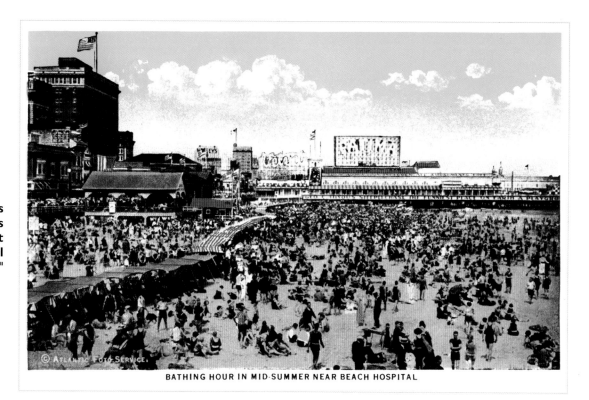

BATHING HOUR IN MID-SUMMER NEAR BEACH HOSPITAL

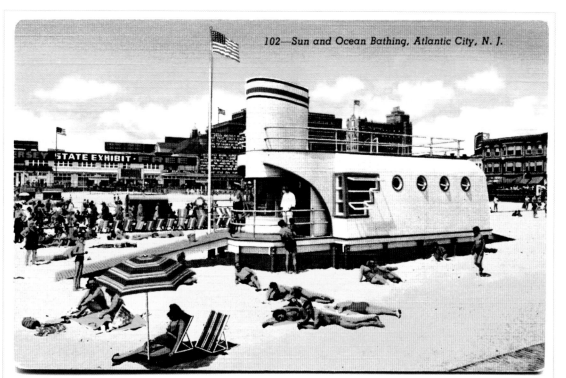

102—Sun and Ocean Bathing, Atlantic City, N. J.

This art deco building on the Atlantic City beach was at Maryland Avenue. It served as Atlantic City's Beach Patrol headquarters.

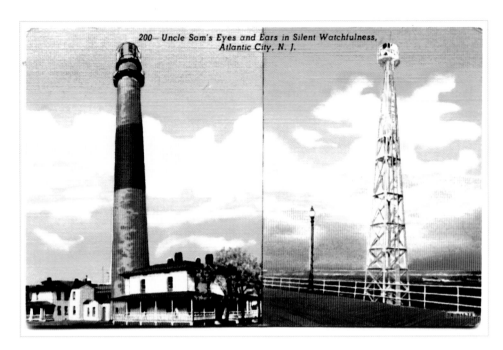

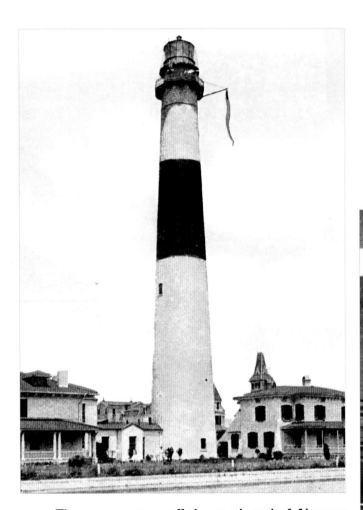

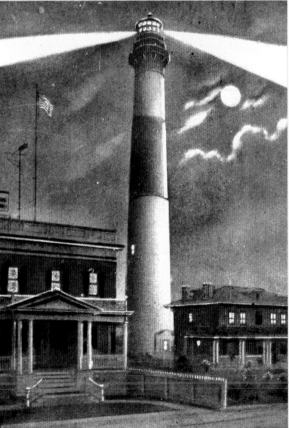

The Absecon Lighthouse was decommissioned by the federal government on July 11, 1933 after a steel tower, at the foot of New Hampshire Avenue, was erected to replace it.

The Absecon Lighthouse was finally built in 1857. It's the tallest lighthouse in New Jersey, and its light can be seen twenty miles out at sea.

The ocean waters off the north end of Absecon Island were some of the most deadly along the East Coast. Between 1847 and 1856, at least sixty-four ships were lost. Dr. Jonathon Pitney, one of the developers of Atlantic City, lobbied the federal government for a lighthouse as early as the 1830s.

Piers

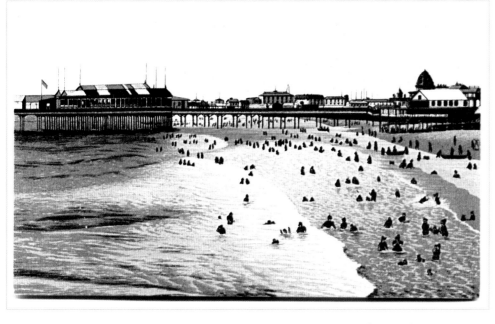

The first amusement pier built over the ocean was Howard's Pier. Constructed by Col. George W. Howard of Baltimore, Maryland, it extended 650 feet into the ocean at the end of Kentucky Avenue. The pier opened to the public July 12, 1882.

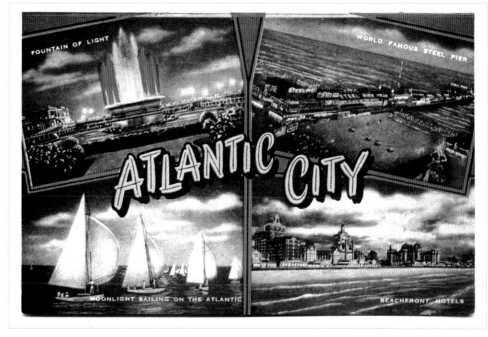

This "Atlantic City" postcard shows the "World Famous Steel Pier" at the top right.

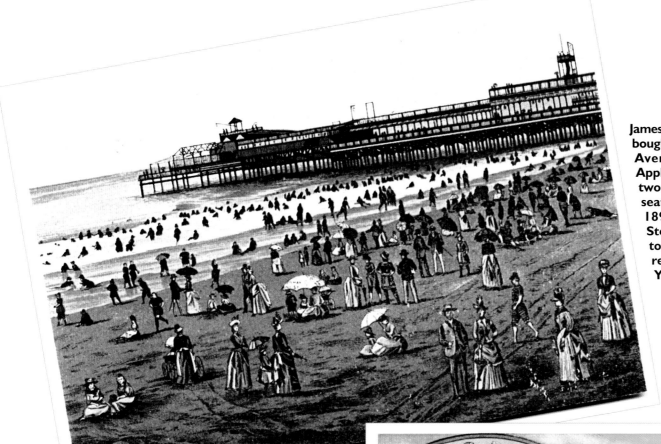

James R. Applegate, a Boardwalk photographer, bought land in front of his gallery at Tennessee Avenue and built a pier 625 feet long. Applegate's Pier opened June 1, 1884 with two decks, which the owner claimed could seat 10,000 people. This pier was sold in 1891 to Captain John Lake Young and Stewart McShea, who changed the name to Young and McShea's Pier. After McShea retired in 1897, the Pier was called simply Young's Pier.

The first pier on iron pilings was built at the end of Massachusetts Avenue by the Atlantic City Ocean Pier Company. The Iron Pier opened April 25, 1886. In 1898, it was sold to the H. J. Heinz Company of Pittsburgh, Pennsylvania to be used as a place to exhibit the company's products.

ENTRANCE TO PIER

HEINZ OCEAN PIER. ATLANTIC CITY
Exhibit of the 57 Varieties Food Products

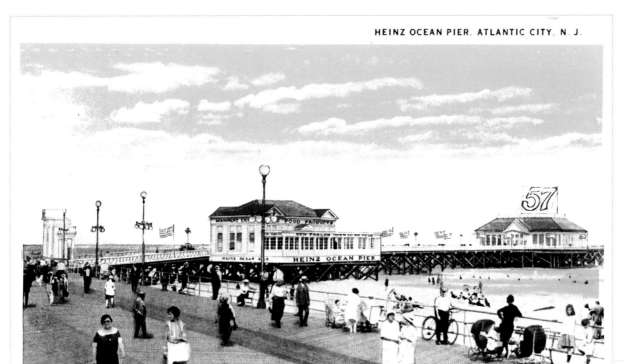

The Heinz Company enlarged the Iron Pier and put on permanent exhibit a complete line of Heinz products. Admission was free and samples of the company's food products as well as souvenirs were given out.

Lectures on food subjects and practical demonstrations were given at Heinz Pier. On September 14, 1944, a hurricane so severely damaged the pier that it was demolished by the Heinz Company.

HEINZ PIER.

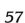

57

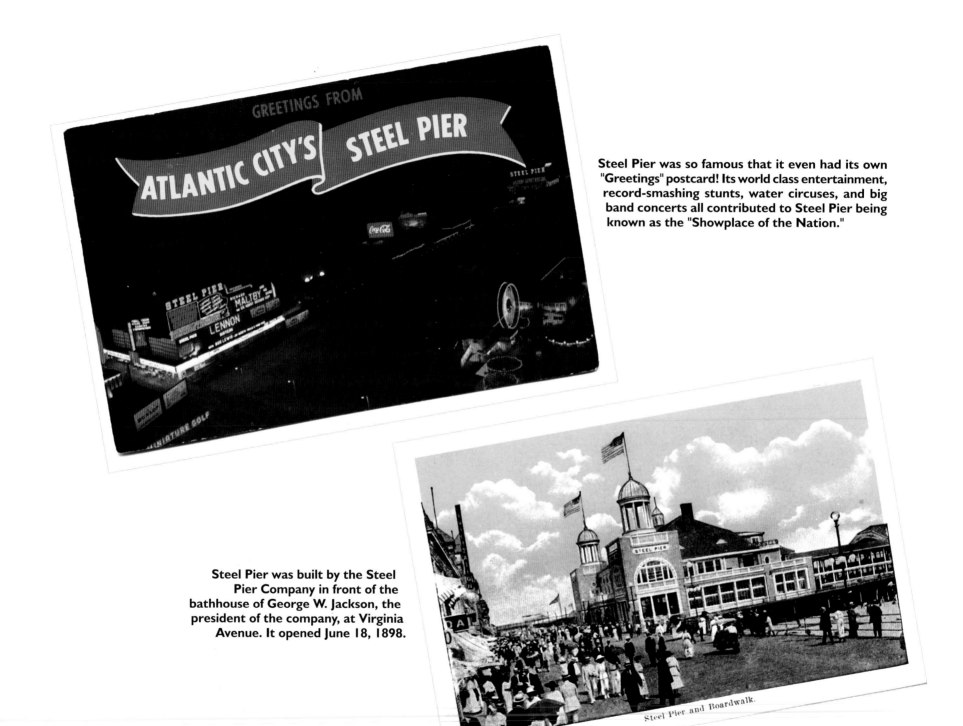

Steel Pier was so famous that it even had its own "Greetings" postcard! Its world class entertainment, record-smashing stunts, water circuses, and big band concerts all contributed to Steel Pier being known as the "Showplace of the Nation."

Steel Pier was built by the Steel Pier Company in front of the bathhouse of George W. Jackson, the president of the company, at Virginia Avenue. It opened June 18, 1898.

Steel Pier and Boardwalk.

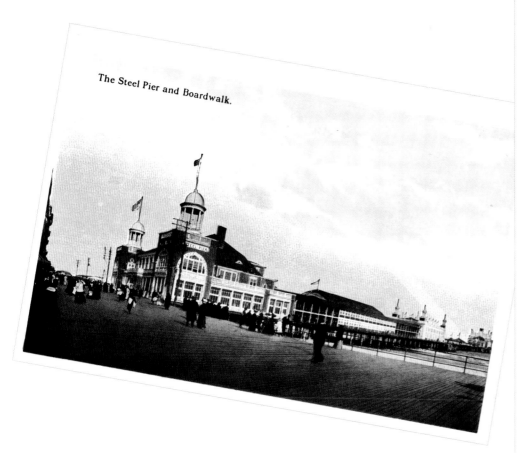

The Steel Pier and Boardwalk.

Steel Pier was lengthened several times to a final 1,780 feet. Many forms of amusement were offered including theatricals and band and orchestra concerts.

Steel Pier's long deck was a favorite place to sit and watch the ocean, beach, and crowd.

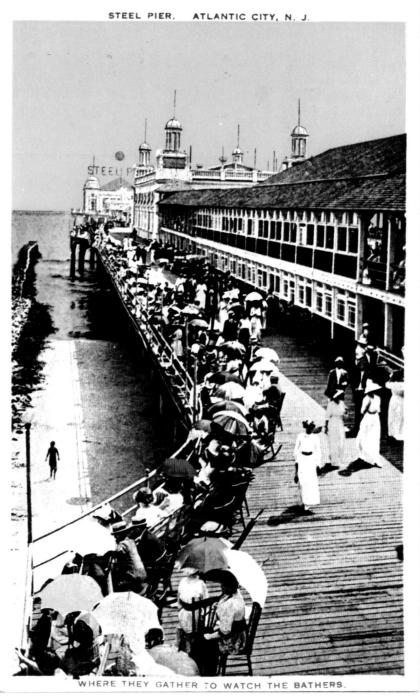

STEEL PIER. ATLANTIC CITY, N. J.

WHERE THEY GATHER TO WATCH THE BATHERS.

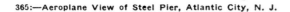
365:—Aeroplane View of Steel Pier, Atlantic City, N. J.

Steel Pier was the most widely advertised amusement pier in the world.

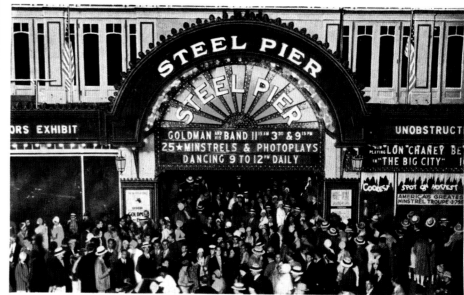
NIGHT VIEW—BOARDWALK ENTRANCE TO THE GENERAL MOTORS EXHIBIT AND THE STEEL PIER

Frank P. Gravatt bought Steel Pier in 1925. He enlarged and improved it and built three theaters. Under his ownership, the Pier became internationally known for its entertainment.

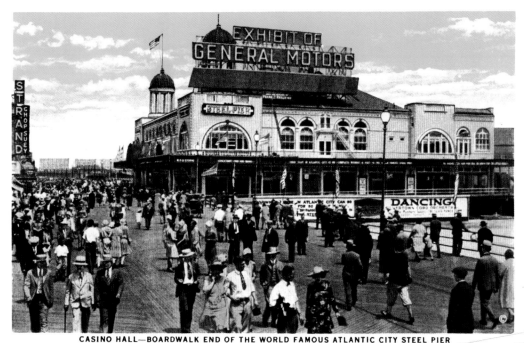

CASINO HALL—BOARDWALK END OF THE WORLD FAMOUS ATLANTIC CITY STEEL PIER

Steel Pier was the site of national conventions and national commercial exhibits. When this photograph was taken, there was an exhibit by General Motors at the Pier.

The General Motors Exhibit at Steel Pier in 1929 highlighted their "Pontiac Big Six 2 door Sedan."

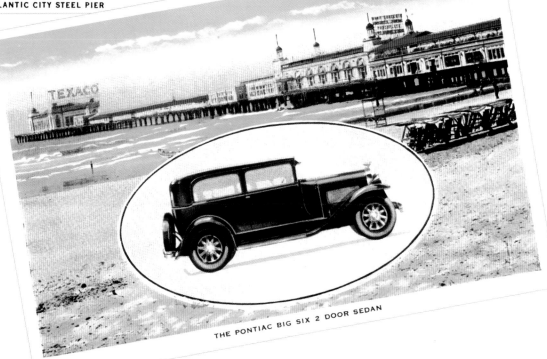

THE PONTIAC BIG SIX 2 DOOR SEDAN

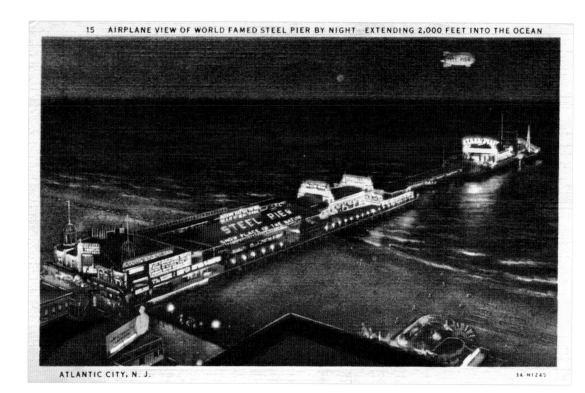

15 AIRPLANE VIEW OF WORLD FAMED STEEL PIER BY NIGHT—EXTENDING 2,000 FEET INTO THE OCEAN

ATLANTIC CITY, N. J.

From the back: "A trip to the end of Steel Pier—a half mile at sea has all the thrill of an ocean voyage with none of the discomforts."

"Steel Pier—A Vacation In Itself!"

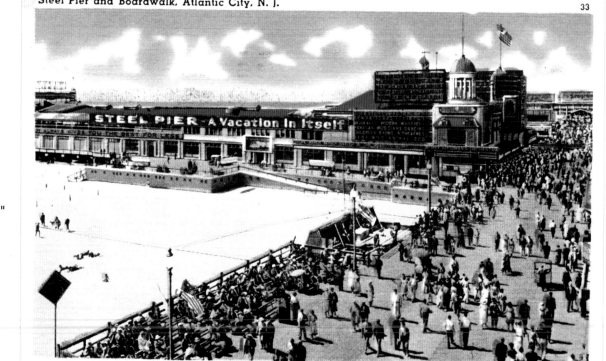

Steel Pier and Boardwalk, Atlantic City, N. J.

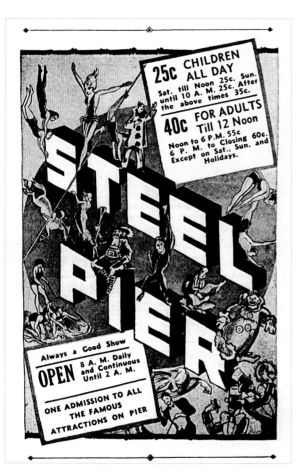

From the back: "The Steel Pier Diving Horses have been a feature of the Steel Pier for years. Never coaxed, driven or urged, these horses dive of their own free will."

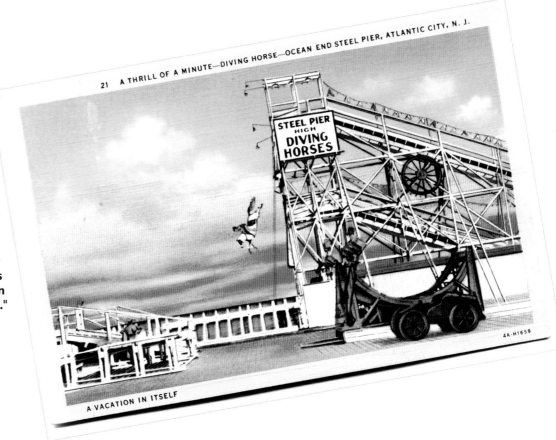

Steel Pier was open from 8 a.m. until 2 a.m. every day. One admission allowed a person into all of the attractions. This 1938 advertisement gives the price of admission for children and adults.

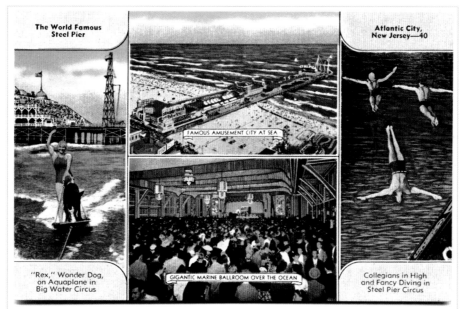

From the back: "Your Atlantic City trip is not complete without a visit to the thrilling water sports, part of Steel Pier's summer attractions."

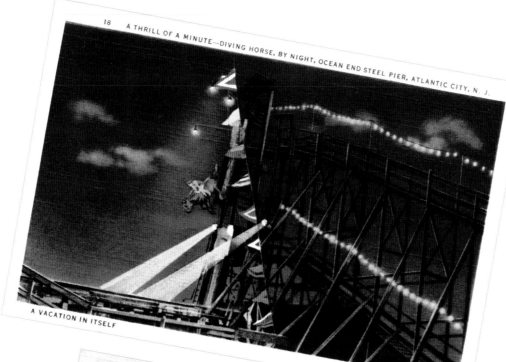

18 A THRILL OF A MINUTE—DIVING HORSE, BY NIGHT, OCEAN END STEEL PIER, ATLANTIC CITY, N. J.

A VACATION IN ITSELF

4A-H1620

Steel Pier's Diving Horses were even more spectacular at night!

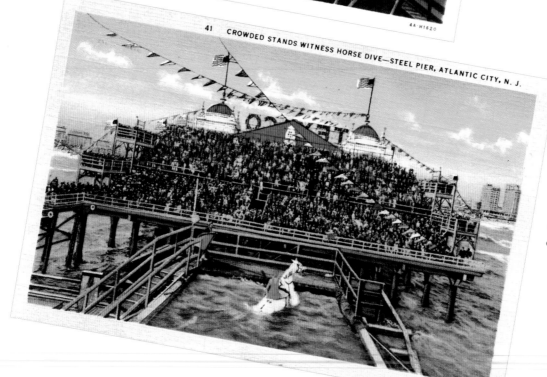

41 CROWDED STANDS WITNESS HORSE DIVE—STEEL PIER, ATLANTIC CITY, N. J.

3A-H1204

From the back: "The water circus at the end of Steel Pier is but a part of the show. If you were to see everything provided by the Steel Pier, you would spend eighteen hours doing so."

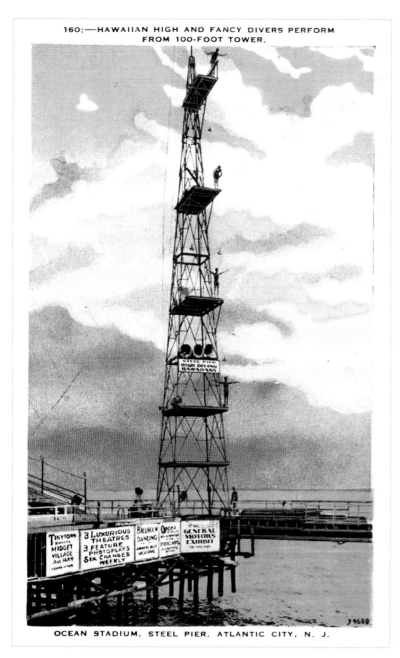

160;—HAWAIIAN HIGH AND FANCY DIVERS PERFORM FROM 100-FOOT TOWER.

OCEAN STADIUM, STEEL PIER, ATLANTIC CITY, N. J.

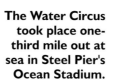

The High Diving Hawaiian Show performed from fifty-foot to one hundred-foot high platforms into the ocean. The height of the platform depended on the wind and water conditions.

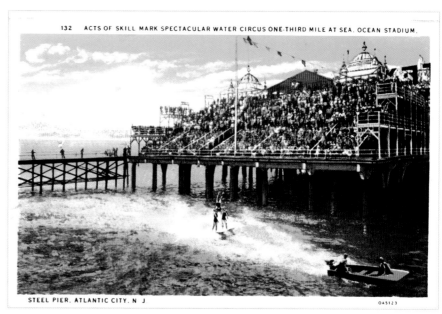

132 ACTS OF SKILL MARK SPECTACULAR WATER CIRCUS ONE-THIRD MILE AT SEA. OCEAN STADIUM.

STEEL PIER, ATLANTIC CITY, N. J.

The Water Circus took place one-third mile out at sea in Steel Pier's Ocean Stadium.

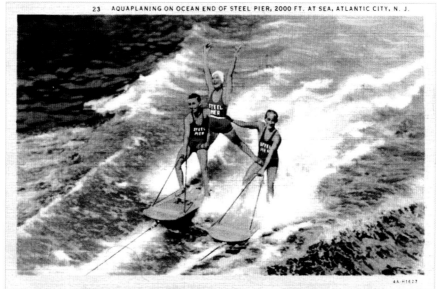

23 AQUAPLANING ON OCEAN END OF STEEL PIER, 2000 FT. AT SEA, ATLANTIC CITY, N. J.

Frank Gravatt, owner of Steel Pier, became known as the "Salt Water Barnum" because of the spectacular water circuses put on at the Pier.

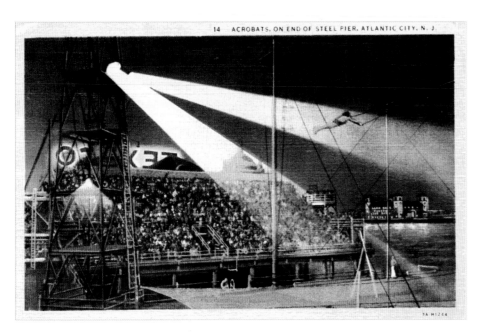

Steel Pier averaged 35,000 visitors a day. The acrobats and Water Circus always drew large crowds.

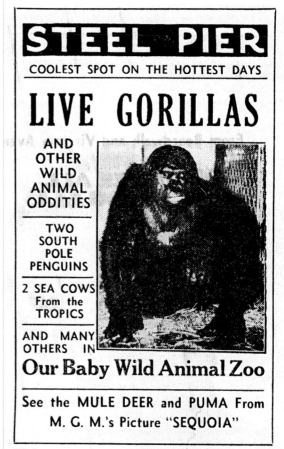

In 1935, Steel Pier exhibited a "Baby Wild Animal Zoo," which included penguins, gorillas, and "two sea cows from the tropics."

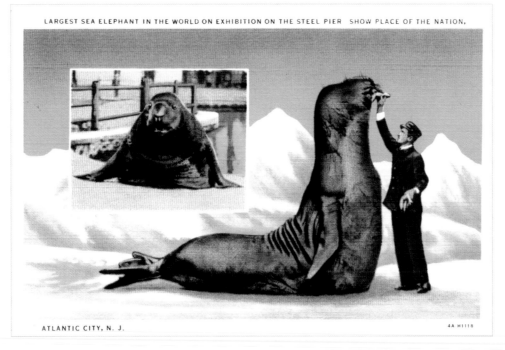

The world's largest sea elephant was exhibited on Steel Pier.

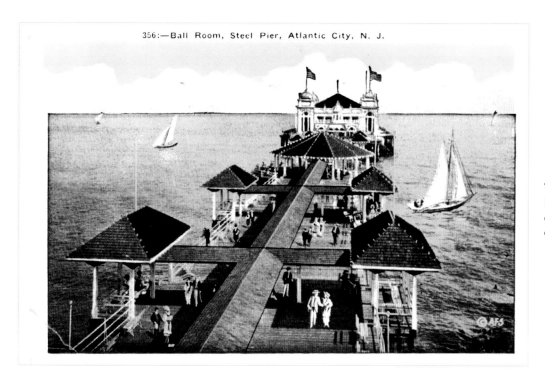

356:—Ball Room, Steel Pier, Atlantic City, N. J.

Visitors enjoyed dancing in the Marine Ball Room, near the end of Steel Pier. It was like dancing on an ocean liner!

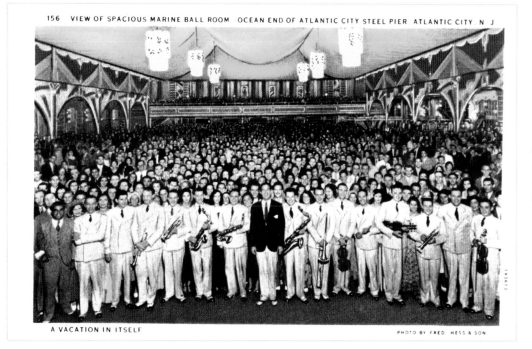

156 VIEW OF SPACIOUS MARINE BALL ROOM OCEAN END OF ATLANTIC CITY STEEL PIER ATLANTIC CITY N J

A VACATION IN ITSELF

PHOTO BY FRED HESS & SON

This view inside the Marine Ball Room shows the band and crowd. There does not appear to be enough room to dance! In 1945, Frank Gravatt sold Steel Pier to George Hamid.

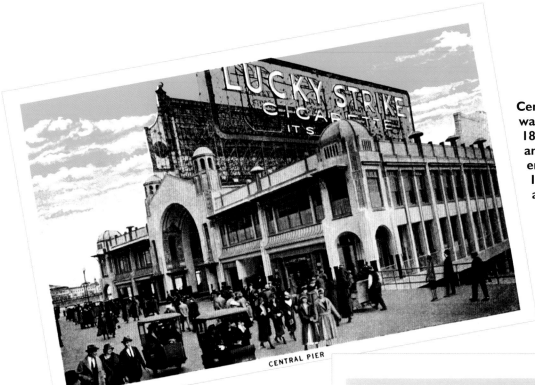

CENTRAL PIER

Central Pier first opened under that name in 1922. It was built as Applegate's Pier in 1884, was lengthened in 1891 when it was known as Young's and McShea's Pier, and again as Young's Ocean Pier in 1897. The Pier was enlarged in 1906 when it opened as Ocean Pier, but in 1912 it suffered a devastating fire. The ruins were all but abandoned until it was rebuilt in 1922 as Central Pier.

Central Pier was used almost exclusively for commercial exhibits. The current exhibit was usually advertised on a huge sign atop the building.

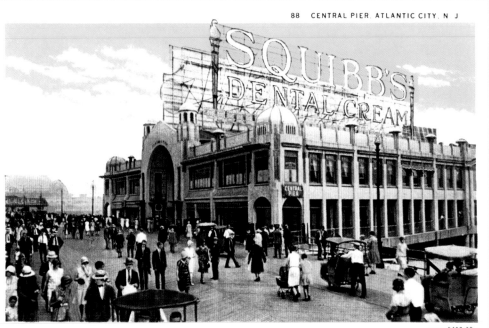

88 CENTRAL PIER. ATLANTIC CITY. N J

5468-29

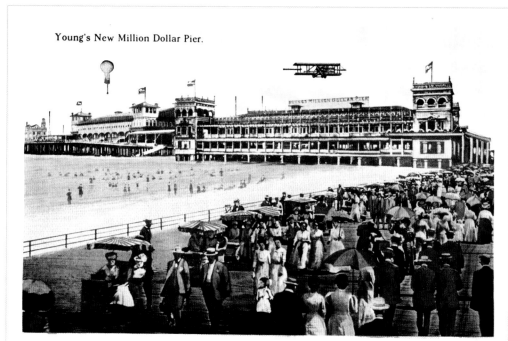

Young's New Million Dollar Pier.

Young's Million Dollar Pier, at the end of Arkansas Avenue, opened July 26, 1904.

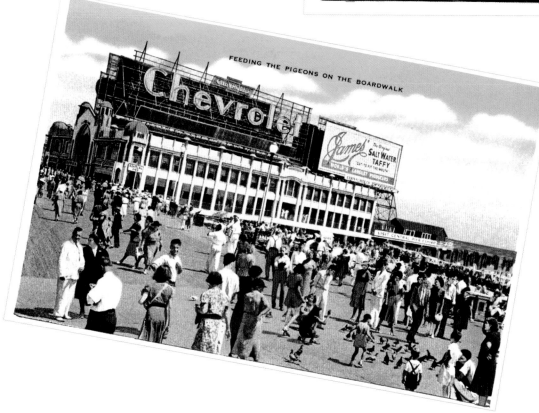

FEEDING THE PIGEONS ON THE BOARDWALK

Shown is a typical crowd on the Boardwalk in front of Central Pier with children feeding the pigeons.

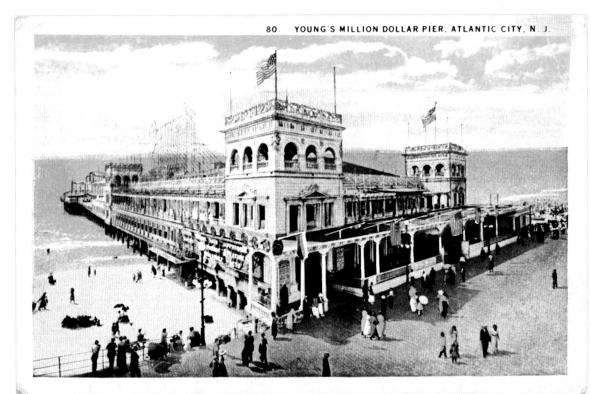

Young's Million Dollar Pier had a grand ballroom, vaudeville, moving pictures, and other amusements.

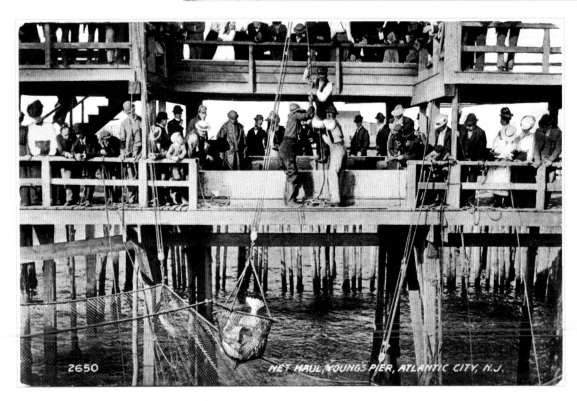

2650

NET HAUL, YOUNG'S PIER, ATLANTIC CITY, N.J.

Young's Million Dollar Pier featured a twice-daily net haul of ocean fish brought in by the fishing boats.

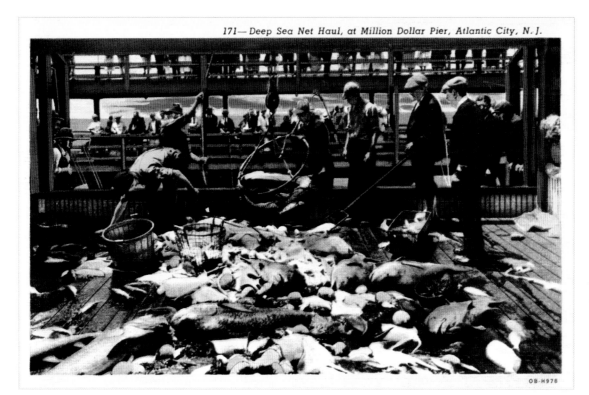

171—Deep Sea Net Haul, at Million Dollar Pier, Atlantic City, N.J.

OB-H978

From the back: "An unusual and instructive sight is the daily net haul of myriad deep sea denizens; varieties ranging from common dog-sharks, tiny sea-horses, rare tropical species to giant fish and mammals."

Captain John L. Young, owner of Young's Million Dollar Pier, built his private residence far out on his pier and gave it the address, No. 1 Atlantic Ocean.

Capt. Young's Residence on Million Dollar Pier.

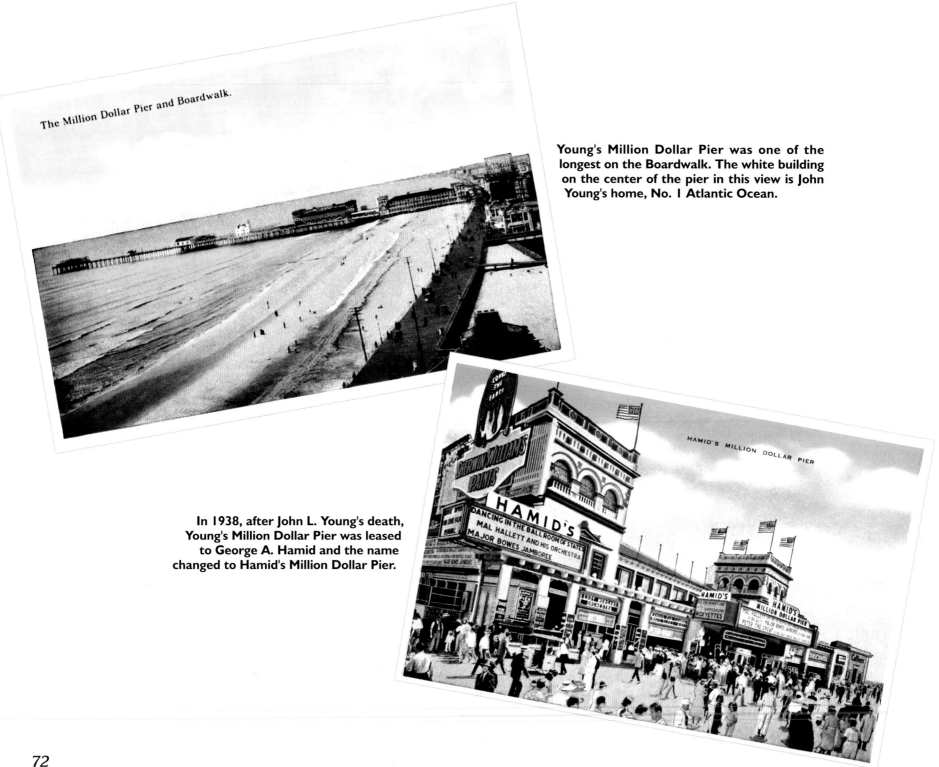

The Million Dollar Pier and Boardwalk.

Young's Million Dollar Pier was one of the longest on the Boardwalk. The white building on the center of the pier in this view is John Young's home, No. 1 Atlantic Ocean.

In 1938, after John L. Young's death, Young's Million Dollar Pier was leased to George A. Hamid and the name changed to Hamid's Million Dollar Pier.

HAMID'S MILLION DOLLAR PIER

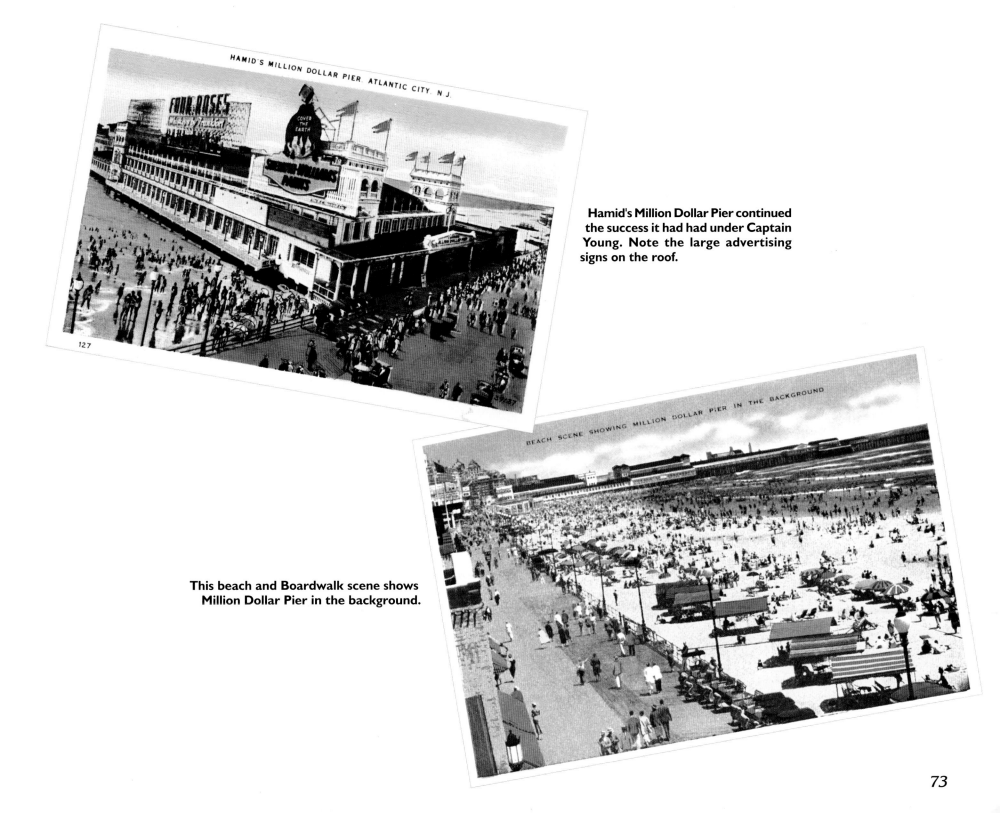

HAMID'S MILLION DOLLAR PIER, ATLANTIC CITY, N.J.

Hamid's Million Dollar Pier continued the success it had had under Captain Young. Note the large advertising signs on the roof.

BEACH SCENE SHOWING MILLION DOLLAR PIER IN THE BACKGROUND

This beach and Boardwalk scene shows Million Dollar Pier in the background.

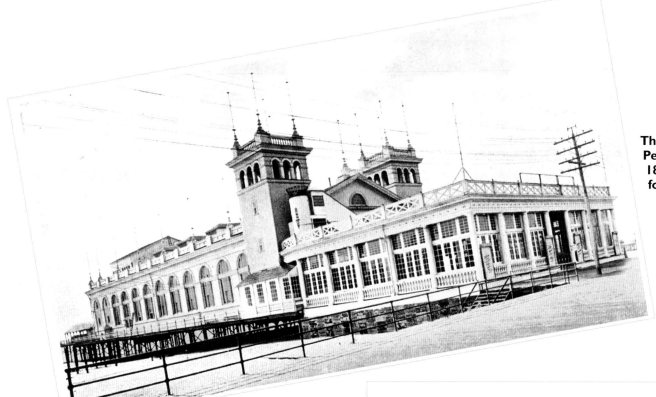

The Auditorium Pier, at the end of Pennsylvania Avenue, was built in 1899 to house a large auditorium for theatricals.

In 1902, the Auditorium Pier was bought by George C. Tilyou.

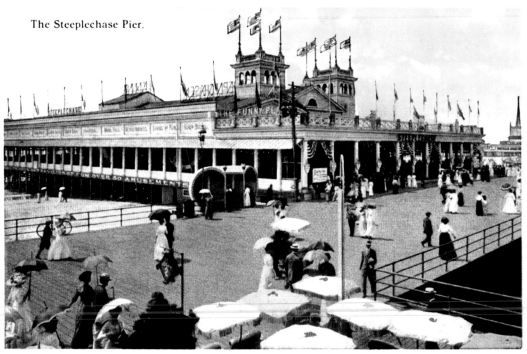

The Steeplechase Pier.

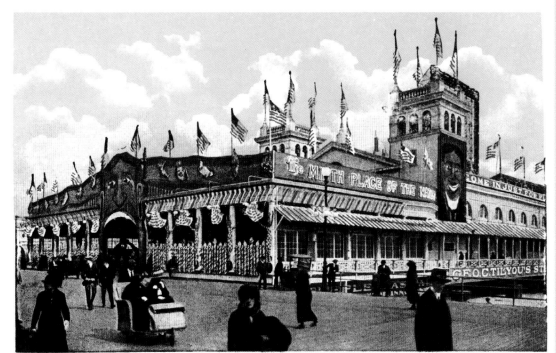

In 1904, George C. Tilyou remodeled his pier as a copy of his famous Steeplechase Pier on Coney Island, and renamed it Steeplechase Pier.

Steeple Chase Pier.

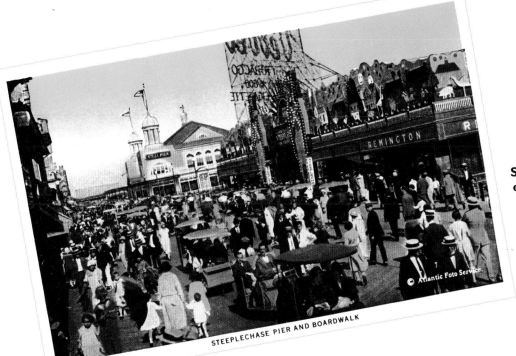

Steeplechase Pier boasted the world's largest electric sign, with 27,000 light bulbs.

STEEPLECHASE PIER AND BOARDWALK

75

DON'T FAIL TO VISIT
GEO. C. TILYOU'S
BEAUTIFUL
Steeplechase Pier

| The Funniest Place on Earth |

Ferris Wheel, Human Roulette, Barrel of Fun, Cave of the Winds, Circle Swing Dragon Ride, Airships, Uncle Sam Swing House of Trouble, Jumbo Slide, Human Mixer, Barrel of Fun, Dragon Gore and GORGEOUS NEW CAROUSEL

25 - Other Attractions - 25

BE SURE THE CHILDREN VISIT **BABYLAND**
See-Saws, Slides and Other Attractions
Free Toys for the Little Ones

Beautiful New BALL ROOM
DANCING Afternoons 3.15 Evenings 8.30
WEDNESDAY EVENING
BIG SURPRISE FEATURE PARTY NIGHT
IN THE BEAUTIFUL NEW BALL ROOM
Sat. Eves–AMATEUR CONTESTS–Open to All–Cash Prizes

This 1915 advertisement for George C. Tilyou's Steeplechase Pier lists the attractions at "The Funniest Place on Earth."

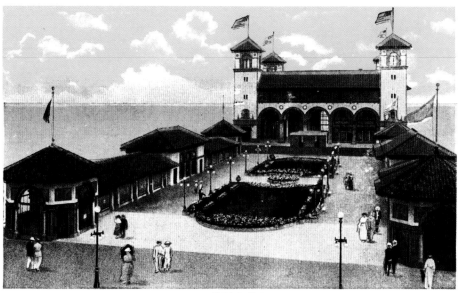

Garden Pier.

Garden Pier, built east of New Jersey Avenue, opened July 19, 1913. It was called Garden Pier because of the flower gardens filling the plaza in front.

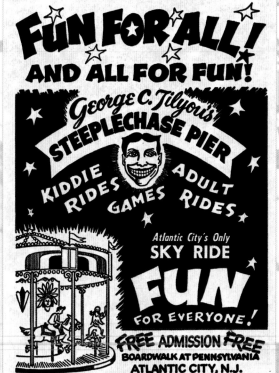

This advertisement sheet from the 1950s for George C. Tilyou's Steeplechase Pier has not changed much from the one used in 1915!

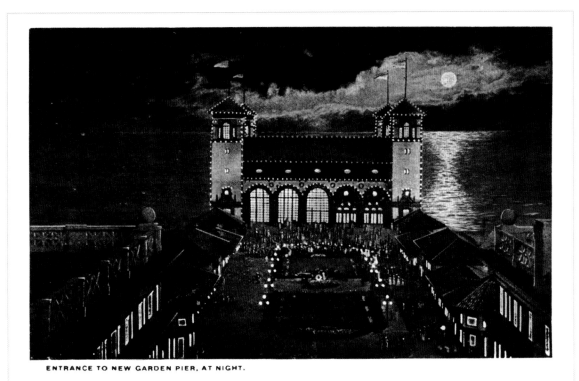

ENTRANCE TO NEW GARDEN PIER, AT NIGHT.

Garden Pier was beautifully lit at night.

Spanish Renaissance architecture and beautiful gardens gave Garden Pier a rather formal appearance, which, with its location away from the downtown, attracted a more "upscale crowd."

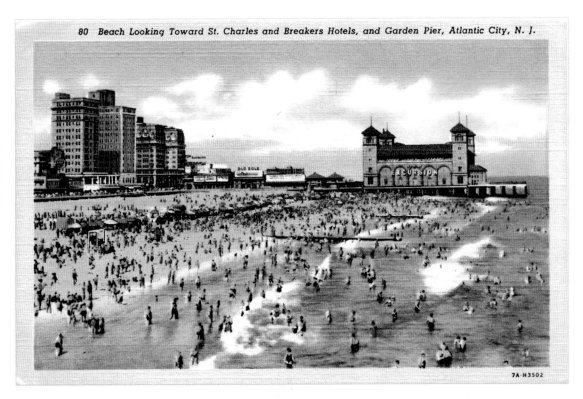

80 Beach Looking Toward St. Charles and Breakers Hotels, and Garden Pier, Atlantic City, N. J.

7A-H3502

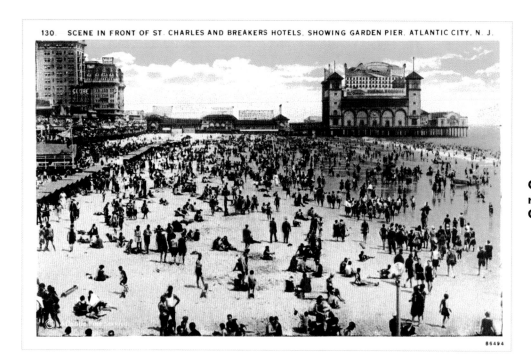

130. SCENE IN FRONT OF ST. CHARLES AND BREAKERS HOTELS, SHOWING GARDEN PIER, ATLANTIC CITY, N. J.

Garden Pier's B. F. Keith's Theater rivaled the theaters in New York City's theater district.

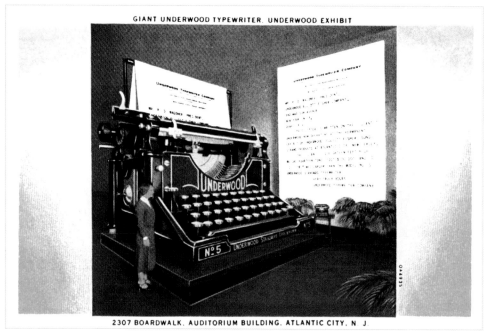

GIANT UNDERWOOD TYPEWRITER, UNDERWOOD EXHIBIT

2307 BOARDWALK, AUDITORIUM BUILDING, ATLANTIC CITY, N. J.

This giant Underwood typewriter was exhibited at Garden Pier beginning in 1916. It was 1,728 times larger than a normal sized typewriter.

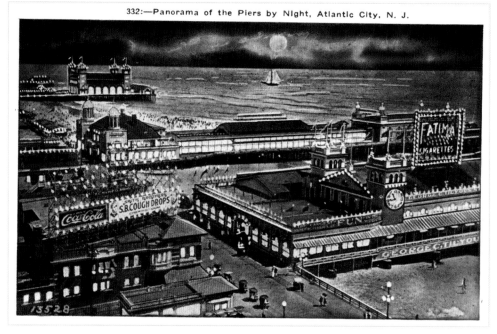

332:—Panorama of the Piers by Night, Atlantic City, N. J.

In this view of the piers at night, George C. Tilyou's Steeplechase Pier is at the bottom, Steel Pier is in the middle, and Garden Pier is at the top.

Chapter Five
Hotels

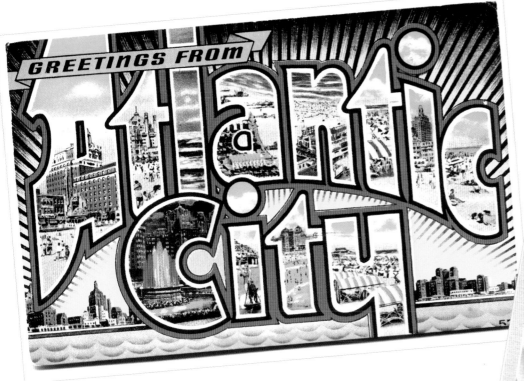

Some of the Boardwalk Hotels along with other sights can be seen on this "Greetings from Atlantic City" postcard.

From the back: "Famed throughout the world is Atlantic City's famous Boardwalk lined with Magnificent Hotels."

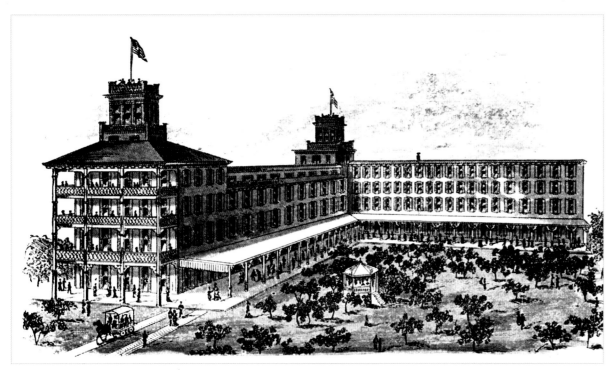

The United States Hotel was one of only five hotels ready to receive visitors when Atlantic City first opened as a resort. It was on the block between Delaware and Maryland Avenues. When it was built, it was the largest hotel in the world, with six hundred rooms, opulent gardens, elegant amenities, and daily concerts. Carts drawn by mules transported guests one block to the beach.

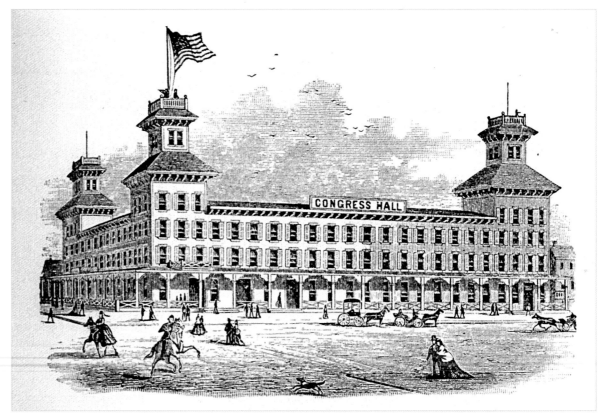

Congress Hall, on the north side of Pacific Avenue, from Massachusetts Avenue to Congress Avenue, was one of the largest hotels built before 1860.

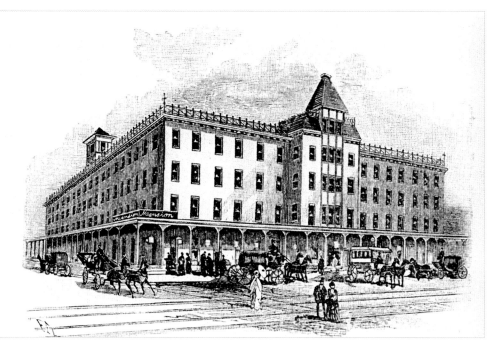

Mansion House, on the southwest corner of Pennsylvania and Atlantic Avenues, was another of the large hotels built before 1860.

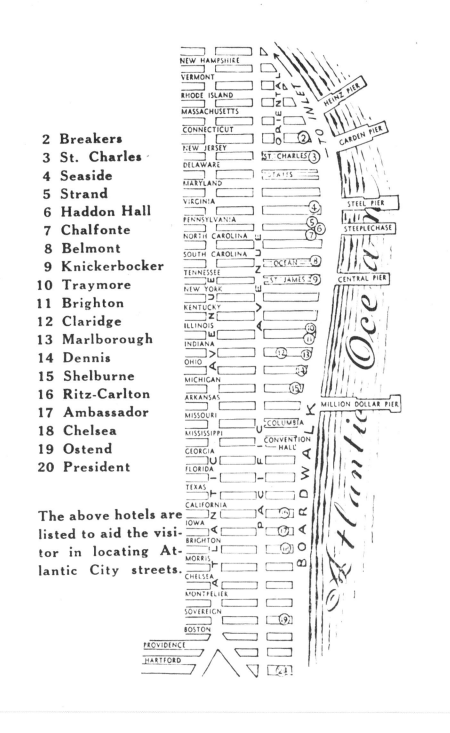

2 Breakers
3 St. Charles
4 Seaside
5 Strand
6 Haddon Hall
7 Chalfonte
8 Belmont
9 Knickerbocker
10 Traymore
11 Brighton
12 Claridge
13 Marlborough
14 Dennis
15 Shelburne
16 Ritz-Carlton
17 Ambassador
18 Chelsea
19 Ostend
20 President

The above hotels are listed to aid the visitor in locating Atlantic City streets.

This 1943 map of hotels and piers on the Atlantic City Boardwalk was made to aid visitors to the resort.

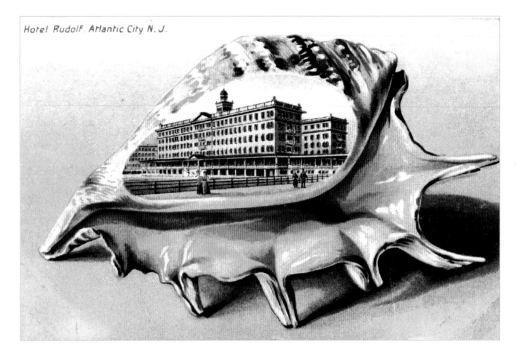

Hotel Rudolf. Atlantic City N.J.

The Hotel Rudolf was built in 1895.

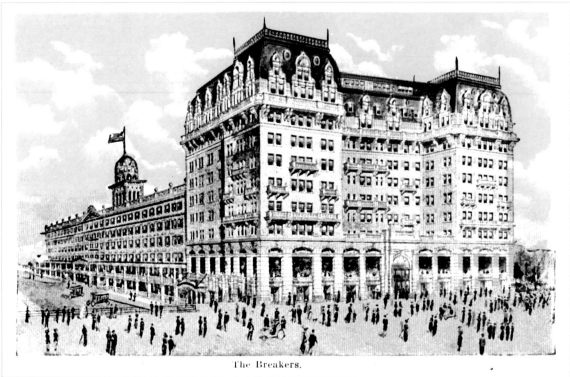

The Breakers.

The Breakers Hotel, on the Boardwalk at New Jersey Avenue, was built as the Hotel Rudolf in 1895. In 1916, when it was taken over as the Breakers Hotel, it opened as a kosher hotel catering to a Jewish clientele.

The St. Charles Hotel, on the Boardwalk at St. Charles Avenue, also had a strictly kosher dining room.

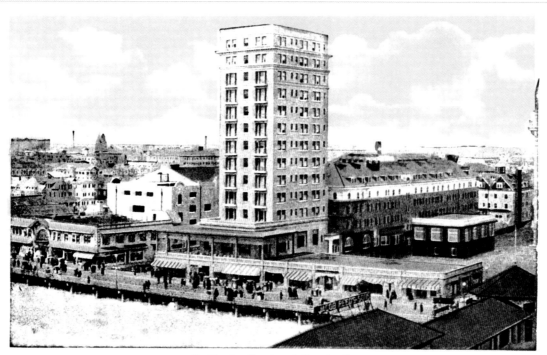

St. Charles Hotel and Boardwalk.

146—ST. CHARLES AND BREAKERS HOTELS, ATLANTIC CITY, N. J.

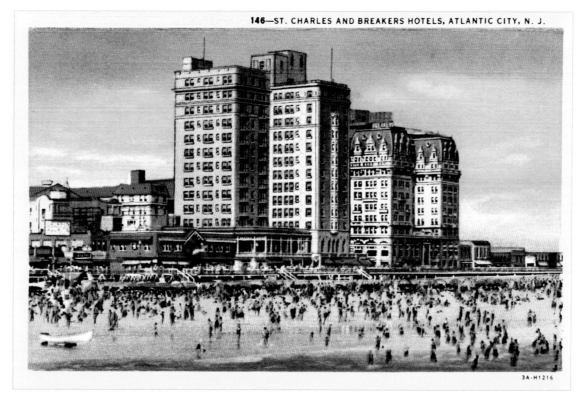

This view of the beach and Boardwalk shows the St. Charles and Breakers Hotels.

3A-H1216

83

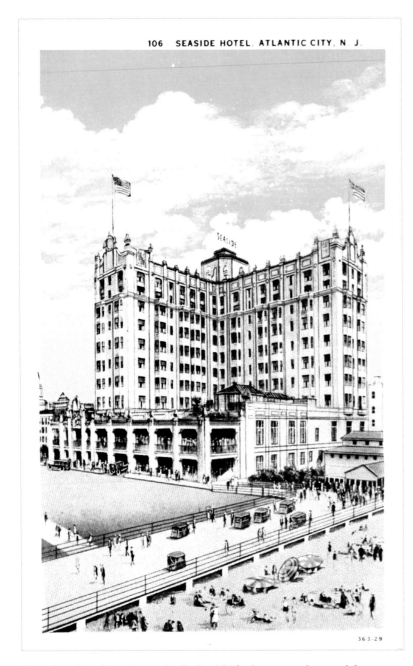

The Seaside Hotel was built in 1862. It was relocated between Virginia and Pennsylvania Avenues in 1865.

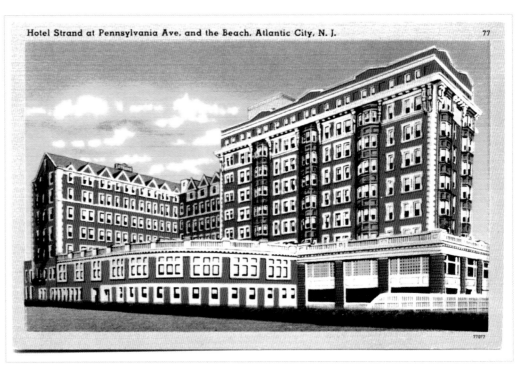

Hotel Strand at Pennsylvania Ave. and the Beach, Atlantic City, N. J. 77

The Strand Hotel gave its address as Pennsylvania (Avenue) and the Beach, just off the Boardwalk.

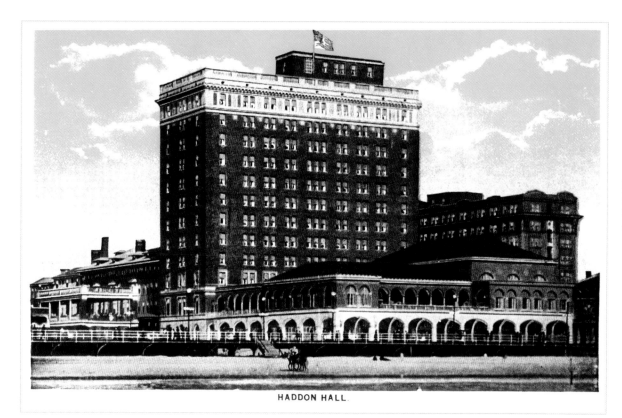

HADDON HALL.

Haddon Hall Hotel opened as Haddon House in 1869. Its name was changed to Haddon Hall soon after 1882. In 1889, it was moved closer to the ocean.

The Chalfonte Hotel opened June 25, 1868. Between 1880 and 1885, it was moved nearer to the ocean.

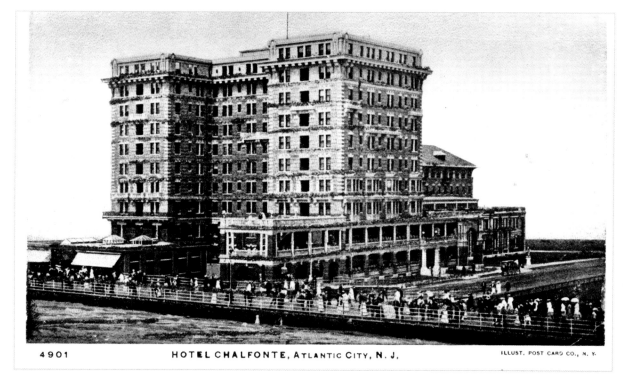

4901 HOTEL CHALFONTE, Atlantic City, N. J. ILLUST. POST CARD CO., N. Y.

85

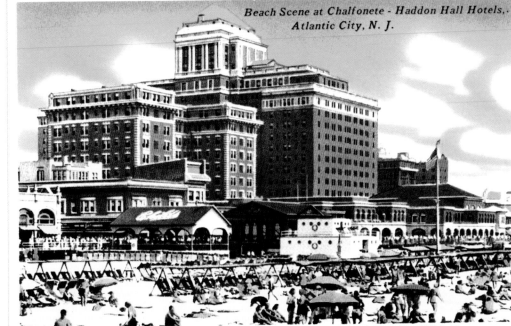

Beach Scene at Chalfonete - Haddon Hall Hotels, Atlantic City, N. J.

When Haddon Hall and the Chalfonte Hotels combined, they became one of the largest hotels in the resort. During World War II the Chalfonte-Haddon Hall served as the Thomas M. England General Hospital, one of the largest military hospitals in the nation.

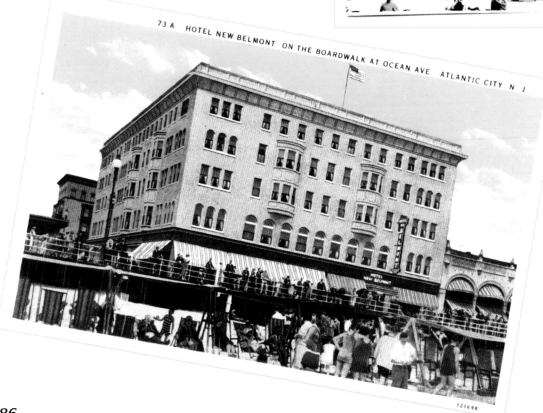

73 A HOTEL NEW BELMONT ON THE BOARDWALK AT OCEAN AVE ATLANTIC CITY N J

The Belmont Hotel, on the Boardwalk at Ocean Avenue was, from the back: "…an example of Atlantic City's finest hotels. It boasts many features for the comfort of its guests."

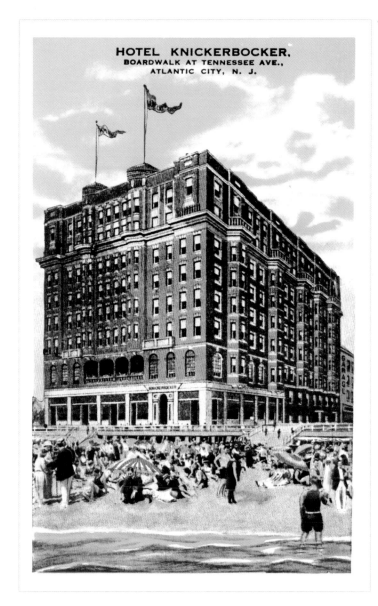

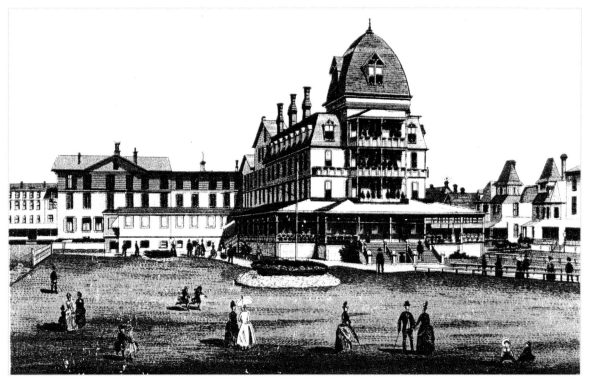

Hotel Traymore was built in 1879 as a ten-room cottage hotel. By 1898, after several additions and improvements, it was the largest of the Resort's hotels.

Hotel Knickerbocker, on the Boardwalk at Tennessee Avenue, was built in 1902 by John L. Young and opened as Young's Hotel. It was the first brick hotel on the Boardwalk. It was later known as the Sterling Hotel. In 1913, the hotel was renamed the "Alamac" by Milton Latz, who ran it for the next ten years. In 1923 it was taken over by the Victor Corporation and again renamed, this time the "Knickerbocker."

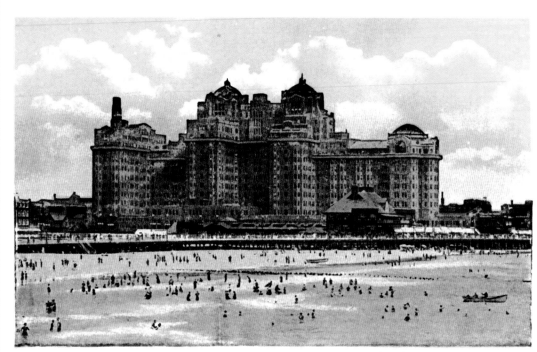

Ocean View, showing Boardwalk and New Traymore Hotel

The new Traymore Hotel, designed by William L. Price of the Philadelphia architecture firm Price and McLanahan, opened in 1915.

The Fountain of Light was built in Brighton Park by the General Electric Company as part of the celebration of the Golden Jubilee of Electric Light. It was given to the city as a permanent memorial on the fiftieth anniversary of electric light on October 21, 1929.

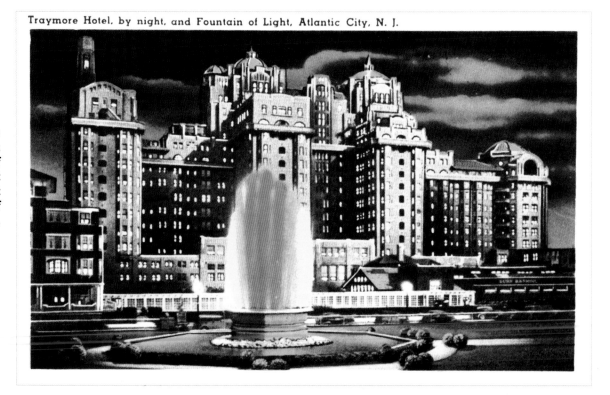

Traymore Hotel, by night, and Fountain of Light, Atlantic City, N. J.

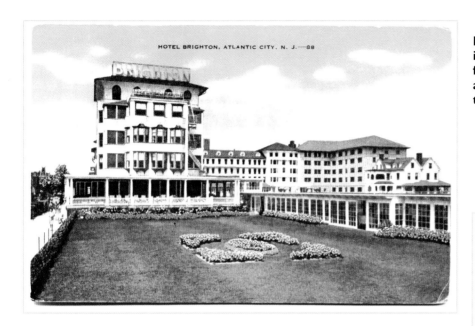

From the back: "Hotel Brighton, facing the Park in a picturesque setting of shrubbery, lawns, and flowers, is noted for its homelike atmosphere and splendid entertainment. It is the home of the Brighton Punch, famous the world over."

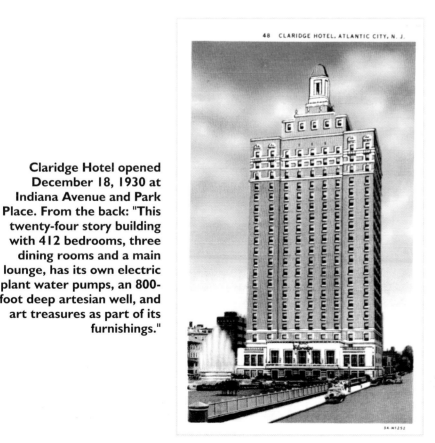

Claridge Hotel opened December 18, 1930 at Indiana Avenue and Park Place. From the back: "This twenty-four story building with 412 bedrooms, three dining rooms and a main lounge, has its own electric plant water pumps, an 800-foot deep artesian well, and art treasures as part of its furnishings."

In 1902 the Josiah White family built Marlborough House on the Boardwalk between Indiana and Ohio Avenues. A few years later, when the adjacent lot became vacant, they built the Blenheim.

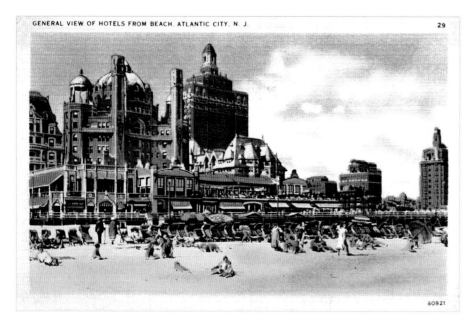

60921

When the Blenheim was built, in 1906, it was one of the first fireproof hotels in Atlantic City and the first to be built of reinforced concrete. Thomas Edison, who invented the process, supervised the job. The Blenheim was also the first to have a private bath for every room.

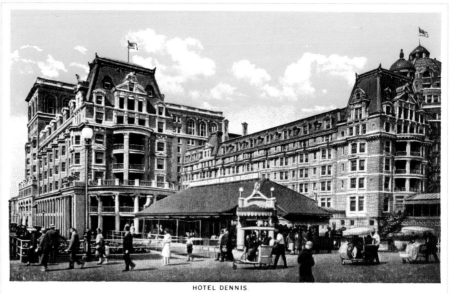

HOTEL DENNIS.

The Dennis Hotel was the oldest hotel name on the beachfront, having started as a two-room cottage at Michigan and Pacific Avenues in 1860 by Professor and Mrs. William Dennis. They gradually enlarged this cottage until it contained forty rooms. On April 11, 1867, they sold it to Joseph H. Borton.

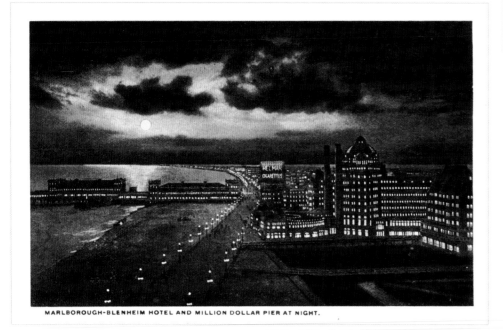

MARLBOROUGH-BLENHEIM HOTEL AND MILLION DOLLAR PIER AT NIGHT.

The two hotels that made up the Marlborough-Blenheim were both designed by Philadelphia architect William L. Price. He designed the Marlborough, named after the Marlborough House in England, the home of the Prince of Wales, in the Queen Anne style. The Blenheim, named after Blenheim Castle, the home of the Duke of Marlborough, was designed in the Spanish-Moorish style.

Joseph Borton moved the Dennis Hotel closer to the beach and in 1892, enlarged it until it had 250 rooms and fifteen private baths. In 1900, Borton sold the hotel to Walter Buzby who continued to enlarge it until it became one of the showplace hotels on the Boardwalk.

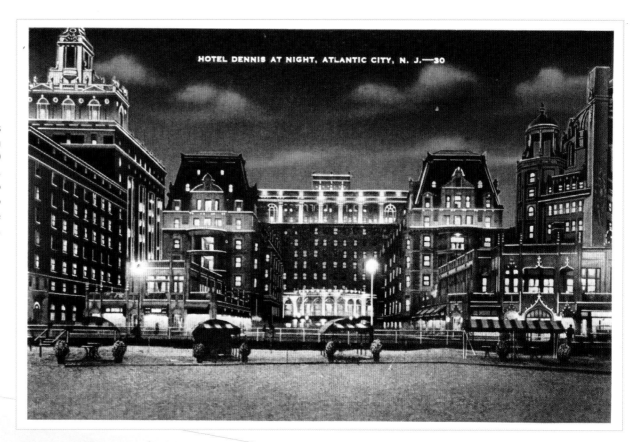

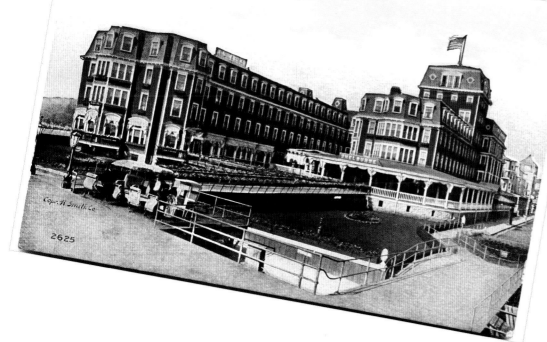

The Shelburne Hotel, on the Boardwalk between Michigan and Arkansas Avenues, began as a rambling wooden structure built by Elisha Roberts of Philadelphia and opened in 1869. In 1904, after Roberts retired from the business, new owner, Jacob Weikel, began his expansion of the hotel. In 1926, Weikel added the tower at a cost of $1,500,000.

91

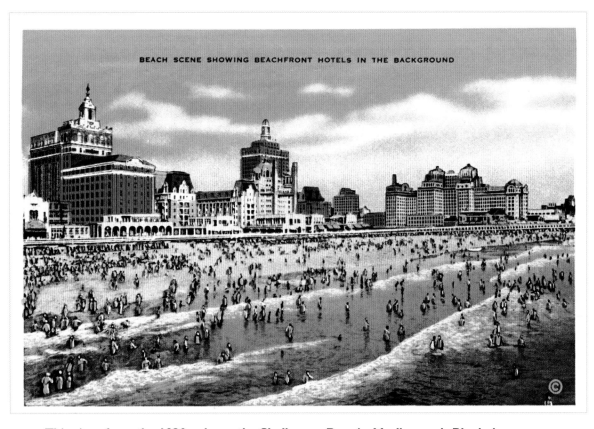

BEACH SCENE SHOWING BEACHFRONT HOTELS IN THE BACKGROUND

This view, from the 1930s, shows the Shelburne, Dennis, Marlborough-Blenheim, Claridge, Brighton, and Traymore Hotels.

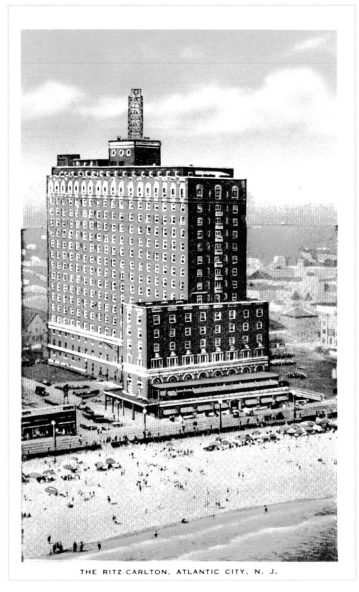

THE RITZ-CARLTON, ATLANTIC CITY, N. J.

The Ritz-Carlton, at Iowa Avenue and the Boardwalk, opened July 21, 1921. Every room had an ocean view, and the hotel advertisements bragged of its famous cuisine and its Merry-Go-Round Bar. It was in that bar that Enoch "Nucky" Johnson, one of the most powerful political bosses in the nation, entertained.

Ambassador Hotel opened in 1919 with seven hundred rooms. The Paul Whiteman Orchestra played at the hotel. While there, they introduced a singing foursome known as the "Rhythm Boys." The group's baritone was named Harry Crosby, who later became famous as Bing.

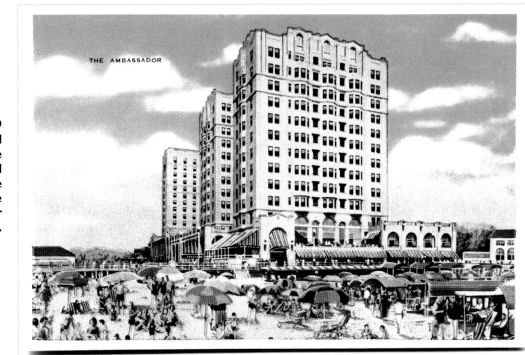

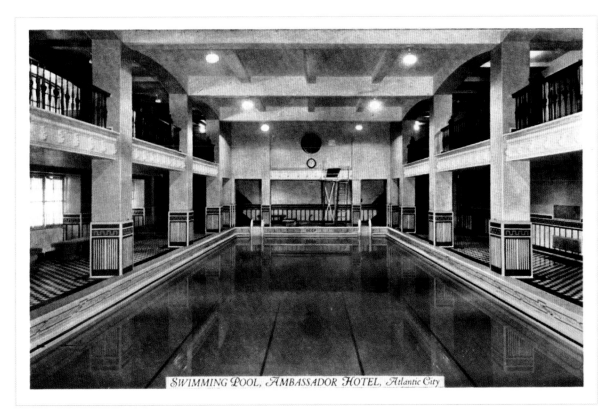

SWIMMING POOL, AMBASSADOR HOTEL, Atlantic City

This scene is of the Ambassador Hotel's indoor swimming pool. From the back: "Try an Ambassador Health Turkish Bath, It's so Simple, yet so Relaxing, so Little Trouble, yet so Worthwhile."

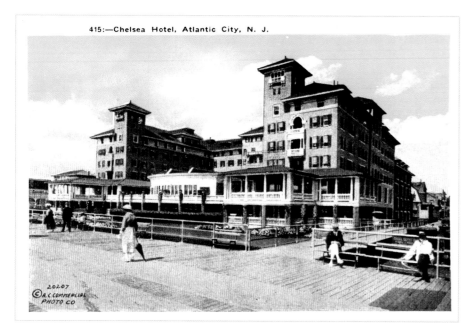

415:—Chelsea Hotel, Atlantic City, N. J.

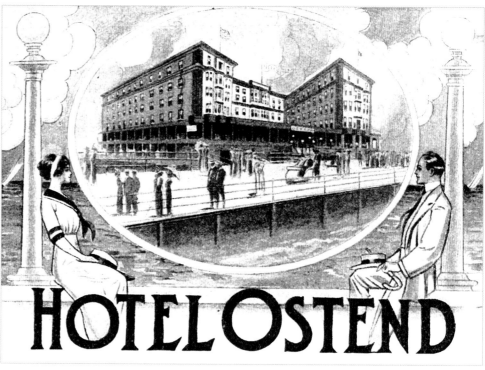

HOTEL OSTEND

The Chelsea Hotel was the first hotel to be built in the downtown. It opened in 1899. The original building was four stories, wood, with 250 rooms, and was built by the J. B. Thompson Company.

Hotel Ostend advertised, from the back, "Where the Surf Sings You to Sleep. The Ostend has the finest location on the Beach. The Hotel is equipped with everything necessary for human comfort and caters to the best patronage."

In 1927, a new twelve-story brick addition to the Chelsea Hotel was built. The Chelsea was the headquarters for Presidents William Howard Taft and Woodrow Wilson. President Franklin D. Roosevelt also stopped there. In this view the old Chelsea Hotel is in the lower left, the brick addition in the center.

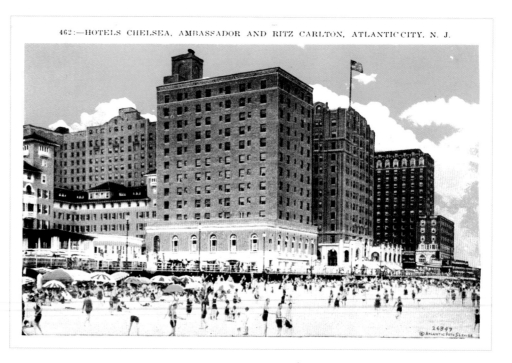

462:—HOTELS CHELSEA, AMBASSADOR AND RITZ CARLTON, ATLANTIC CITY, N. J.

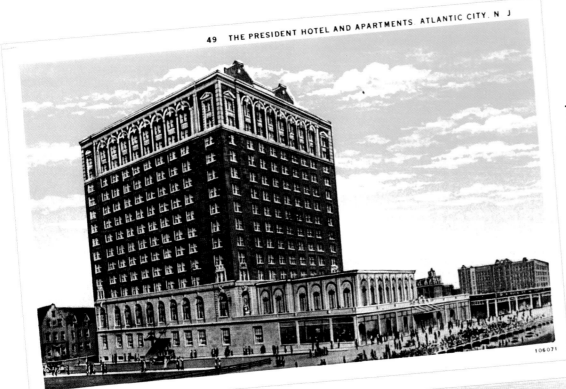

106071

The President Hotel and Apartments was on the Boardwalk at Albany Avenue. From the back: "500 Rooms with Sea Water Baths, American and European Plans, Sea Water Swimming Pool, Surf Bathing from Hotel, Also Beautifully Furnished housekeeping Apartments by the Week, Month, or Year."

This view, taken from an airplane, shows most of the large hotels on the Boardwalk.

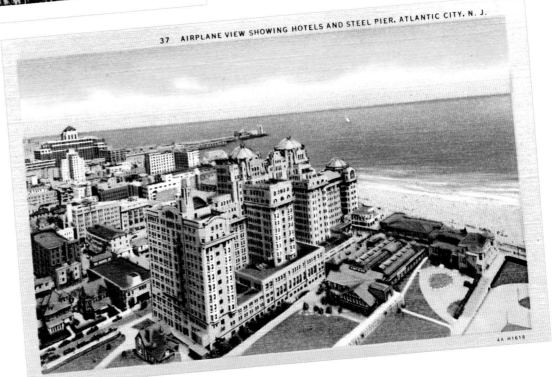

4A H1618

95

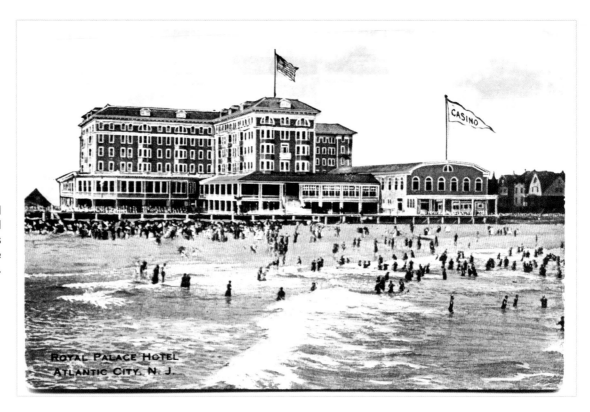

The Royal Palace Hotel and Casino, at Pacific Avenue and the Boardwalk, had views from most rooms of the ocean and Absecon Inlet.

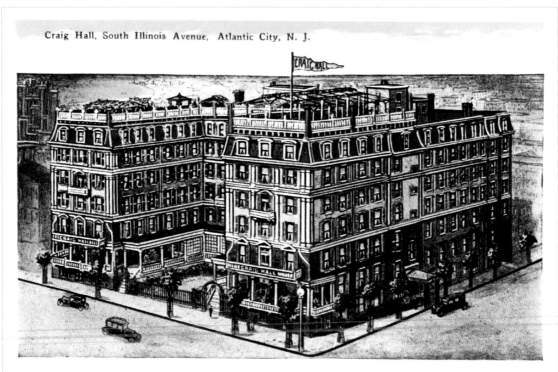

Craig Hall, at Illinois and Pacific Avenues, was the first hotel in Atlantic City that was over one hundred feet high. It was torn down in 1936 to build the Post Office.

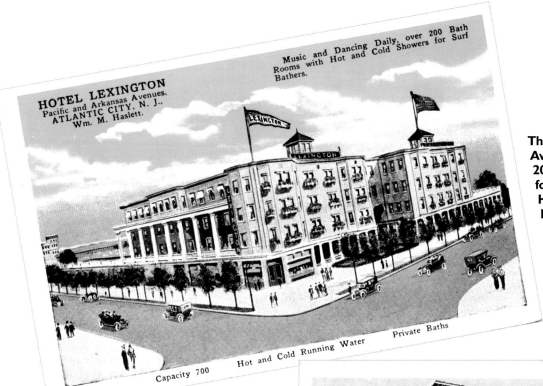

The Lexington Hotel, at Pacific and Arkansas Avenue, had, "Music and Dancing Daily, over 200 Bath Rooms with Hot and Cold Showers for Surf Bathers." From the back: "Only One Half Block from Million Dollar Pier and Best Bathing Beach. Fire Proof Garage."

The Hotel Morton, at Virginia Avenue near the beach, advertised, from the back, "Near World Famous Steel Pier and Steeplechase Pier."

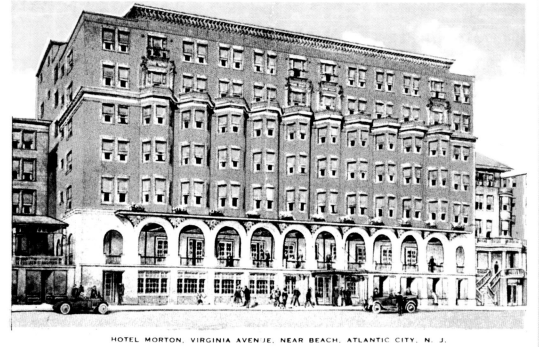

HOTEL MORTON, VIRGINIA AVENUE, NEAR BEACH, ATLANTIC CITY, N. J.

97

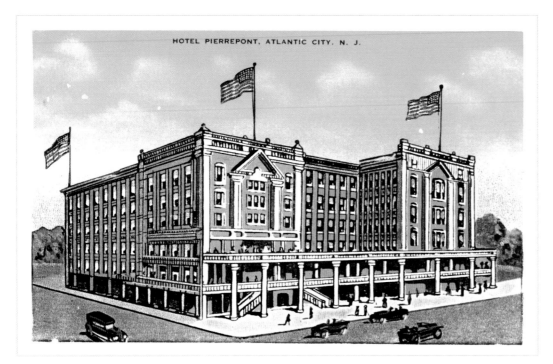

HOTEL PIERREPONT, ATLANTIC CITY, N. J.

The Hotel Pierrepont advertised, from the back, "Easy Access to Beach and Boardwalk, Fine Dining, Hot and Cold Showers for Surf Bathers."

The Hotel Park Central, on South Tennessee Avenue, advertised, from the back, "Well Managed Hotel, Moderate Prices, the Famous WILROSE RESTAURANT on Premises Where Many Tasty Dishes Await You at Surprisingly Low Menu Prices."

Chapter Six
Restaurants

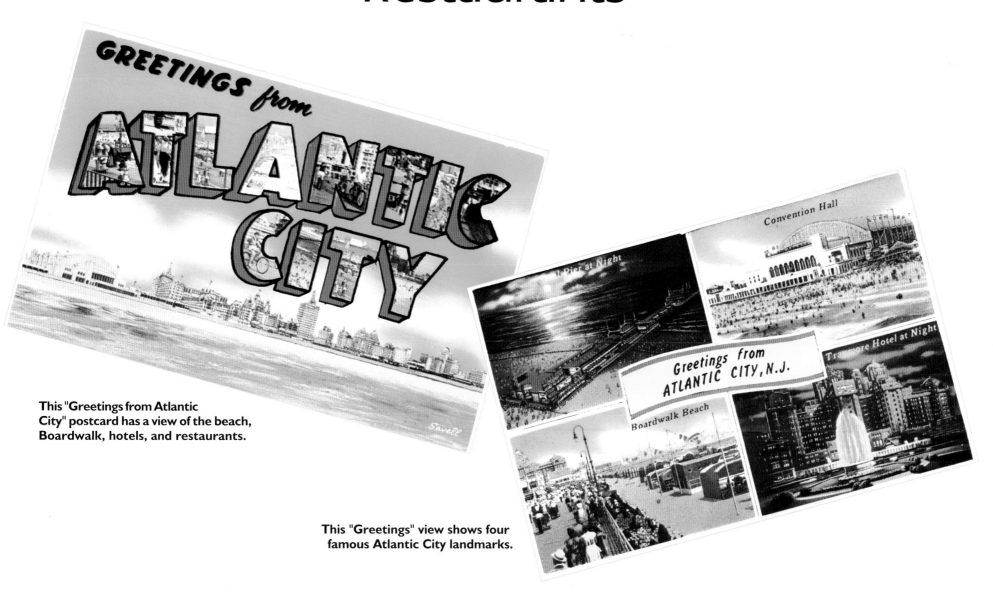

This "Greetings from Atlantic City" postcard has a view of the beach, Boardwalk, hotels, and restaurants.

This "Greetings" view shows four famous Atlantic City landmarks.

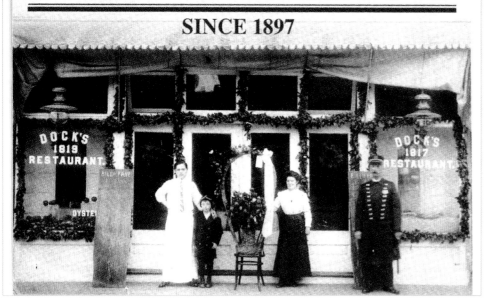

DOCK'S OYSTER HOUSE
SINCE 1897

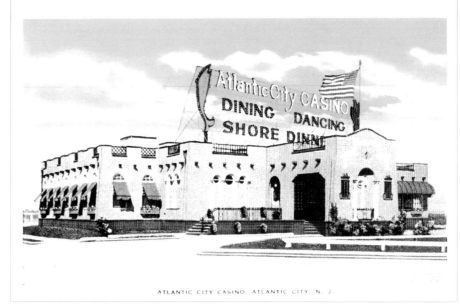

The Atlantic Casino, from the back: "Dinner from $1.00, High-Class Vaudeville Entertainment, Sea Food our Specialty, Dancing with LEROY SMITH and His Orchestra."

Opened in 1897 and named Dock's by owner, Harry "call me Dock" Dougherty, Dock's Oyster House was an immediate success. At 2405 Atlantic Avenue, the restaurant was an easy walk from the Boardwalk.

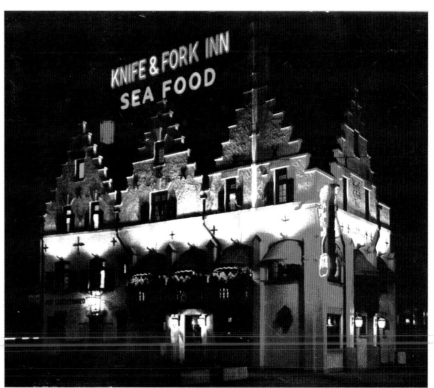

The Knife and Fork Restaurant, on the corner of Albany and Pacific Avenues, was opened in 1912 by Milton Latz. A steak and chop house, the restaurant immediately attracted crowds with its fine menu and interesting décor.

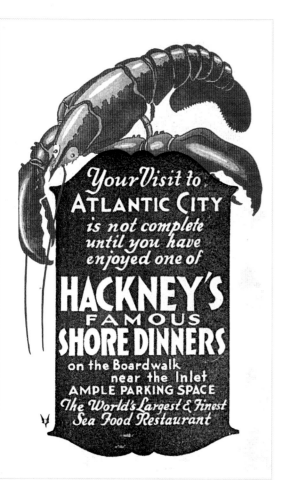

Hackney's, on the Boardwalk near the Inlet, billed itself as, "The World's Largest & Finest Sea Food Restaurant."

Hackney's Sea Food Restaurant could seat 3,200 people in its dining room. In 1943, it was recognized worldwide when it hosted meals for representatives from more than forty-three countries while they were in Atlantic City with the United Nations Relief and Rehabilitation Administration.

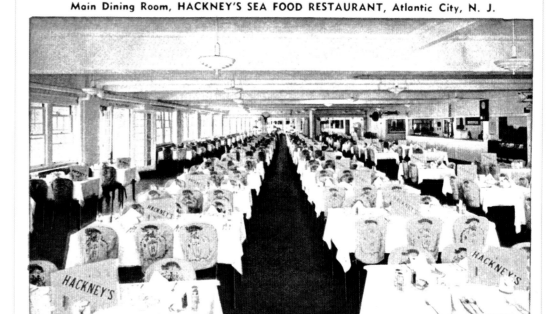

Main Dining Room, HACKNEY'S SEA FOOD RESTAURANT, Atlantic City, N. J.

Seating Capacity, Three Thousand Two Hundred

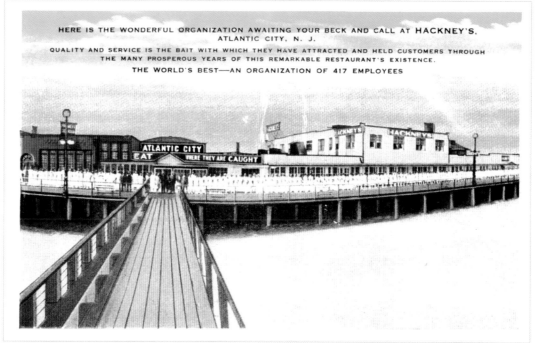

HERE IS THE WONDERFUL ORGANIZATION AWAITING YOUR BECK AND CALL AT HACKNEY'S, ATLANTIC CITY, N. J.

QUALITY AND SERVICE IS THE BAIT WITH WHICH THEY HAVE ATTRACTED AND HELD CUSTOMERS THROUGH THE MANY PROSPEROUS YEARS OF THIS REMARKABLE RESTAURANT'S EXISTENCE.

THE WORLD'S BEST—AN ORGANIZATION OF 417 EMPLOYEES

Founded in 1912, by Harry Hackney, the restaurant grew in size and fame until it was, "As Famous as the Boardwalk."

101

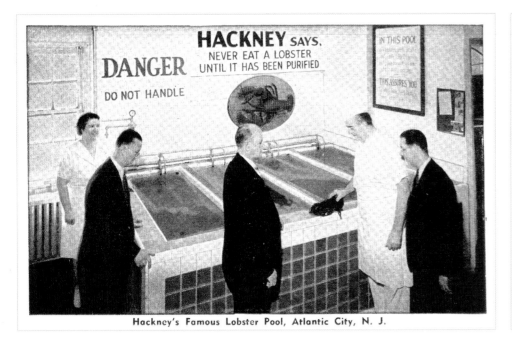

Hackney's Famous Lobster Pool, Atlantic City, N. J.

This postcard offers several views of Capt. Starn's Seafood Restaurant and Bar. The restaurant opened June 26, 1940.

Hackney's lobsters were famous. From the lobster pool in the restaurant lobby, each patron could choose a lobster to have cooked and served.

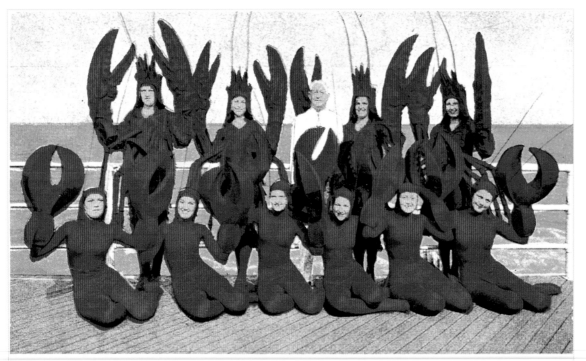

"Lobster King Harry Hackney with his Lobster Waitresses who won the Prize in Atlantic City's Famous Beauty Pageant Parade on the Atlantic City Boardwalk." Hackney's was a fun place to work!

Lobster King Harry Hackney with his Lobster Waitresses who won the Prize in Atlantic City's Famous Beauty Pageant Parade on the Atlantic City Boardwalk

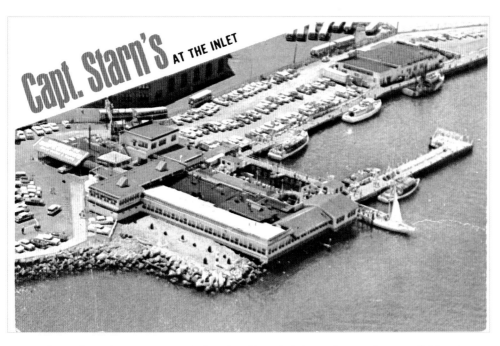

Capt. Starn's was on the Inlet. It offered sightseeing and sport fishing boats and moonlight sailing.

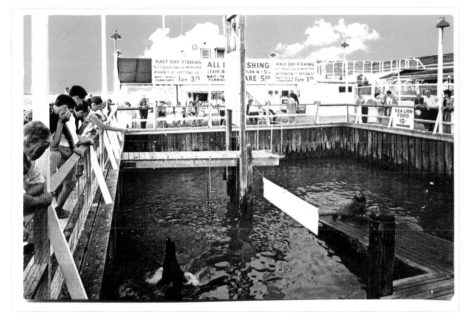

At Capt. Starn's, patrons could feed the seals in pens, just outside the dining room, as they waited for their table.

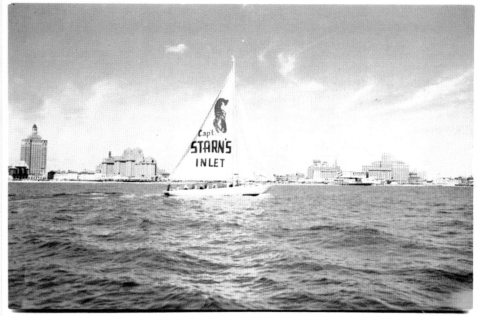

This view shows the sailboat used not only for sightseeing, but also to advertise Capt. Starn's Restaurant.

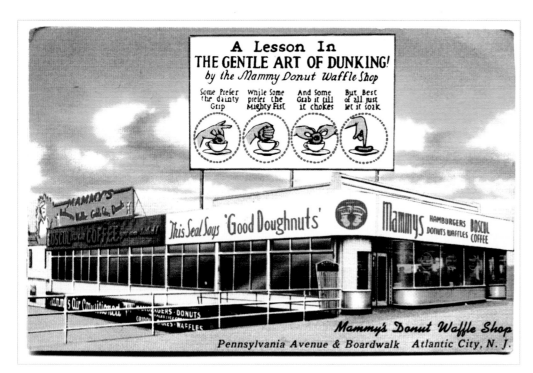

Mammy's Donut Waffle Shop was at Pennsylvania Avenue and the Boardwalk at Steeplechase Pier. It was famous for the sign on top of the restaurant showing, "The Gentle Art of Dunking."

One of the KENTS RESTAURANTS in Atlantic City

KENTS RESTAURANT
—UPTOWN—
1214 ATLANTIC AVE. AT N. CAROLINA AVE.

Kents Restaurants, from the back: "A Visit to Atlantic City is Made Happier by Eating Regularly at Kents!"

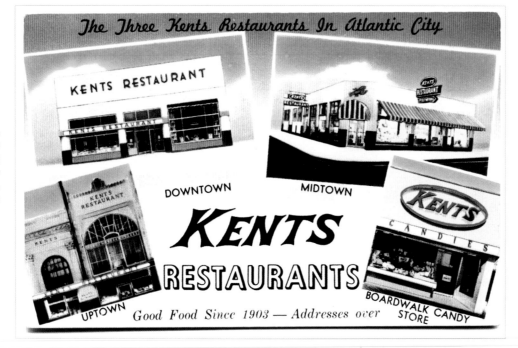

Kents Uptown was at 1214 Atlantic Avenue at North Carolina Avenue. From the back: "In the Heart of the City, Don't miss taking home a box of Kents Chocolate Brownies."

Kents Downtown Restaurant was at 2124-28 Atlantic Avenue, across from the railroad station, near Convention Hall. From the back: "Kents Restaurants, Sea Food Fresh from the Ocean. As Modern as Tomorrow."

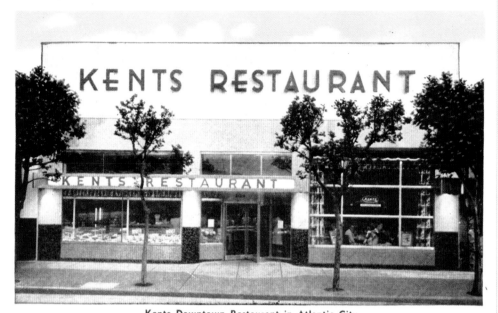

Kents Downtown Restaurant in Atlantic City
2124-28 Atlantic Ave., Opposite Railroad Station - Two Minutes from Convention Hall

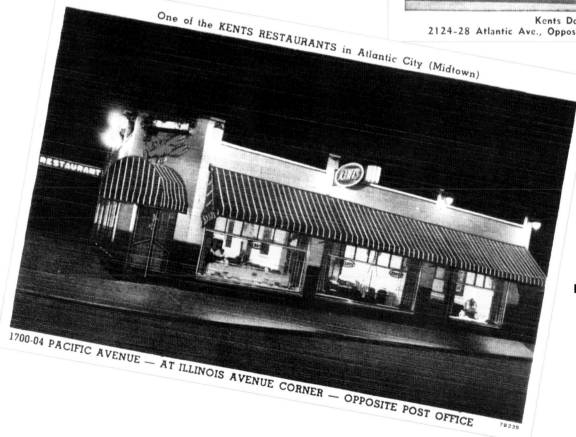

One of the KENTS RESTAURANTS in Atlantic City (Midtown)

1700-04 PACIFIC AVENUE — AT ILLINOIS AVENUE CORNER — OPPOSITE POST OFFICE

79235

Kents Midtown Restaurant was at the corner of Pacific and Illinois Avenues, across from the Post Office. From the back: "Steaks from Prime meats, Chops Broiled to a Delicious Brown, Famous Fried Chicken Dinners."

Absecon Inlet

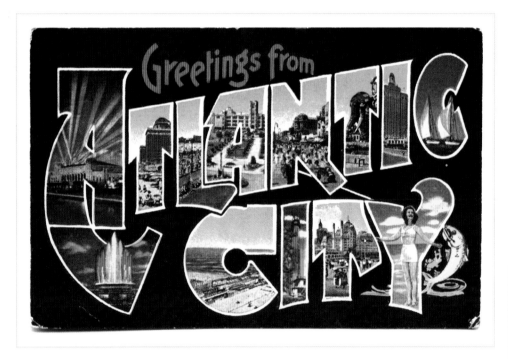

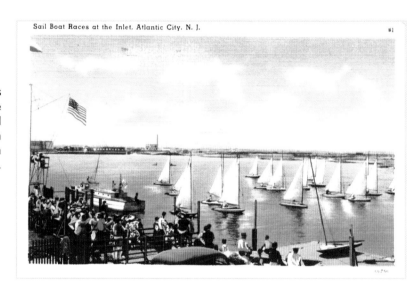

Sailboats races were held several times each summer on the Inlet.

From the fish at the bottom right corner, to the sailboat at top right, this "Greetings from Atlantic City" postcard shows it all!

This "Greetings" postcard has scenes from Absecon Inlet, Atlantic City's world famous beaches, and in-town sights.

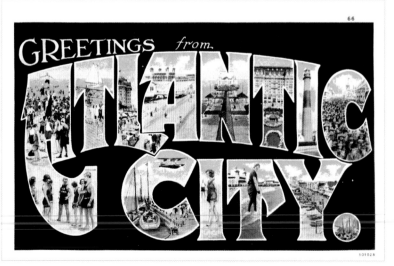

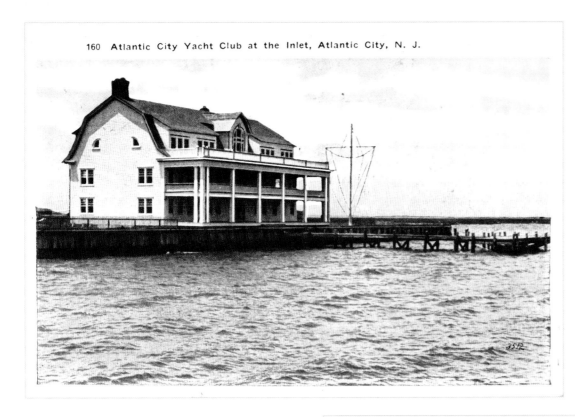

160 Atlantic City Yacht Club at the Inlet, Atlantic City, N. J.

The Atlantic City Yacht Club on Absecon Inlet was the clubhouse for the yachting crowd.

This view shows fishermen returning with their catches at night.

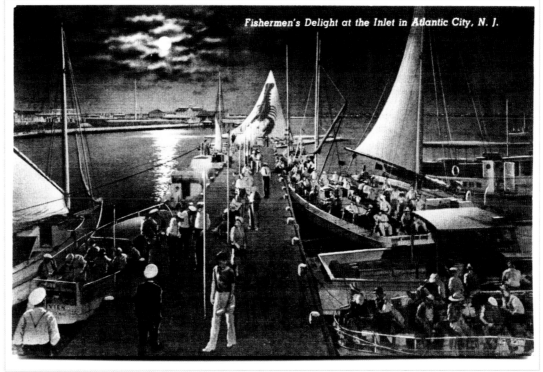

Fishermen's Delight at the Inlet in Atlantic City, N. J.

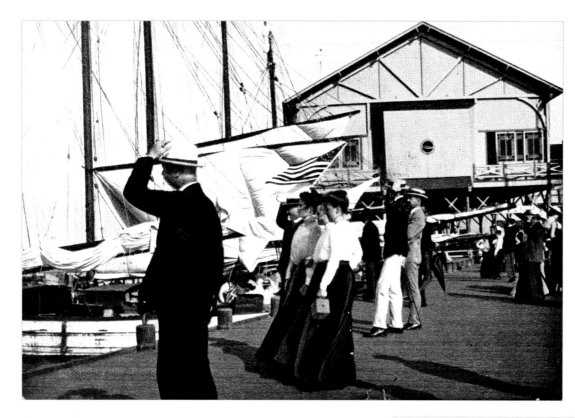

Shown… watching the fishermen and boats from the Inlet pier.

A view of the yachting pier at Absecon Inlet.

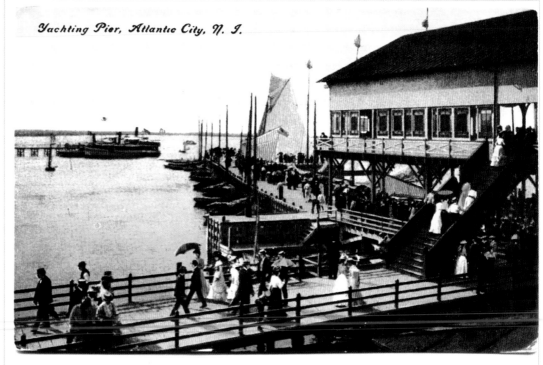

Yachting Pier, Atlantic City, N. J.

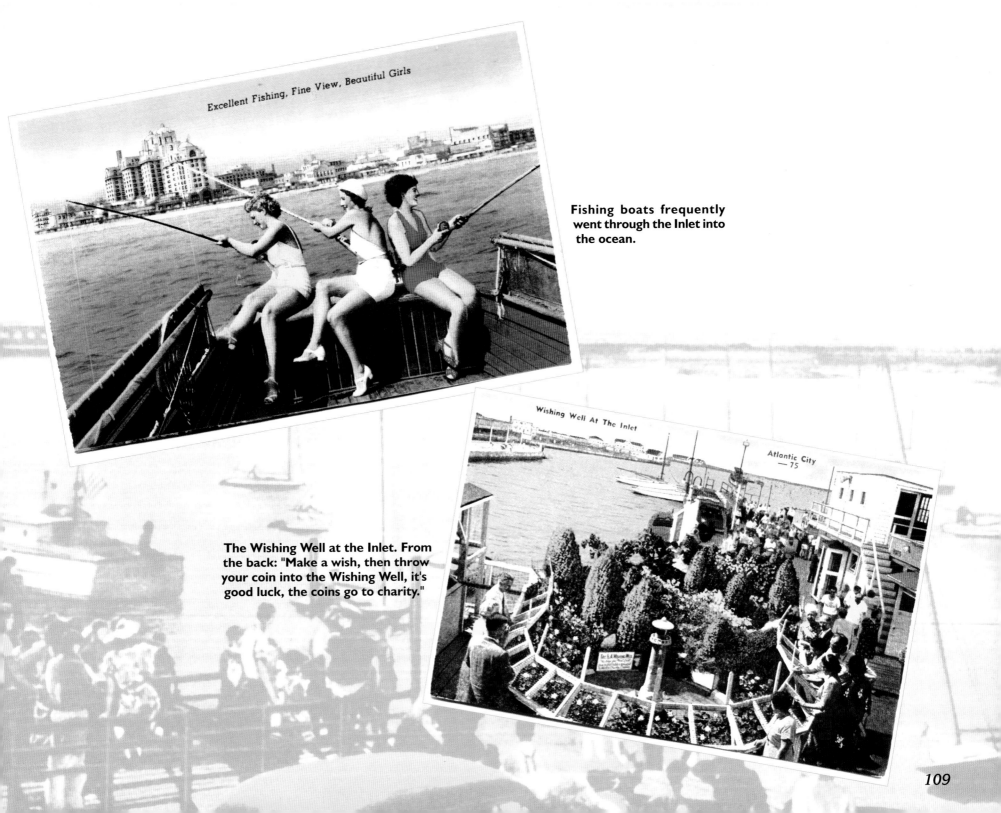

Excellent Fishing, Fine View, Beautiful Girls

Fishing boats frequently went through the Inlet into the ocean.

Wishing Well At The Inlet

Atlantic City — 75

The Wishing Well at the Inlet. From the back: "Make a wish, then throw your coin into the Wishing Well, it's good luck, the coins go to charity."

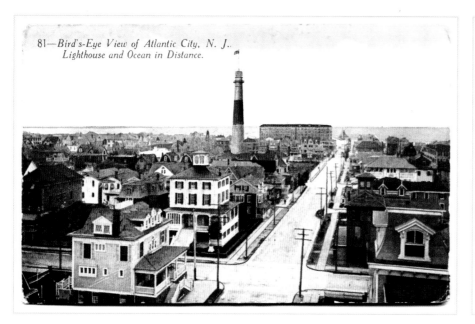

This view looks towards the Absecon Inlet.

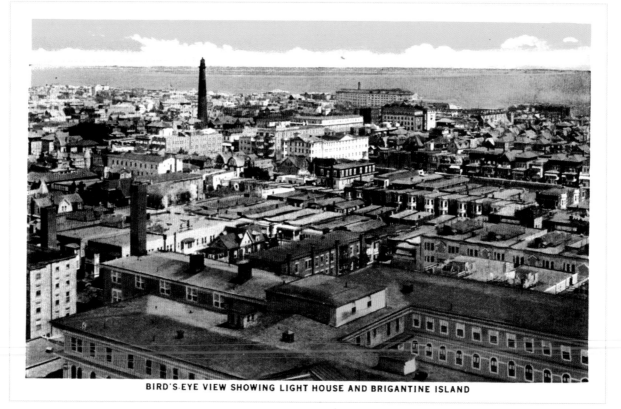

Another view looking toward the Inlet.

Brigantine, across the Absecon Inlet from Atlantic City, can be seen in the distance.

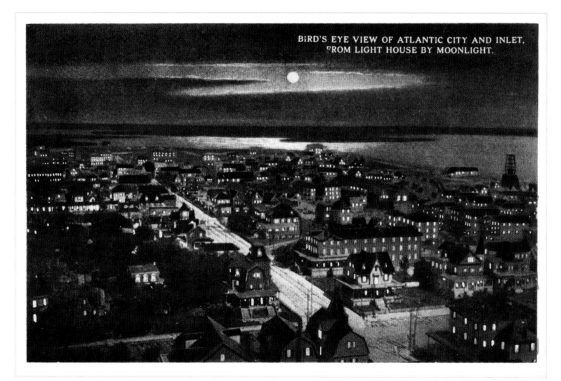

This view, taken from the Absecon Lighthouse at night, shows Atlantic City and the Inlet. Brigantine can be seen in the distance.

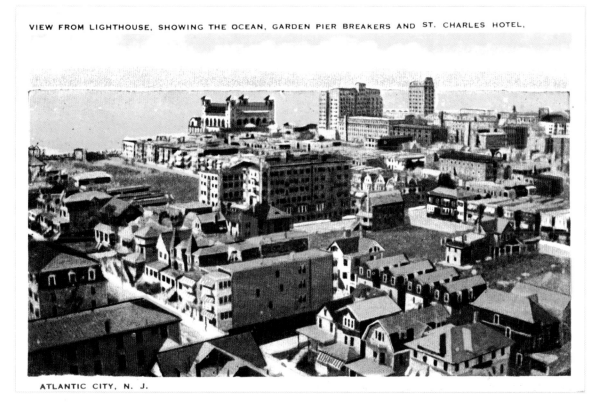

This view, taken from the Absecon Lighthouse during the day, shows Garden Pier, top left; Breakers Hotel, center; and St. Charles Hotel on right, all on the oceanfront.

Community

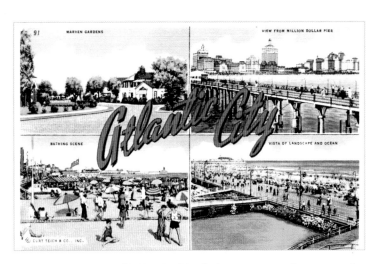

Welcome to "Atlantic City;" these scenes showcase the community.

This "Atlantic City" postcard shows buildings important to the community and its citizens.

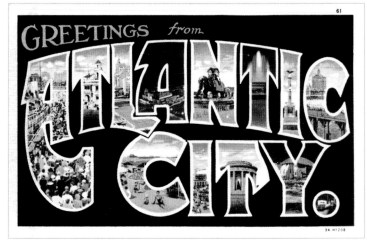

This "Greetings from Atlantic City" scene has views of some of the City's monuments and memorials.

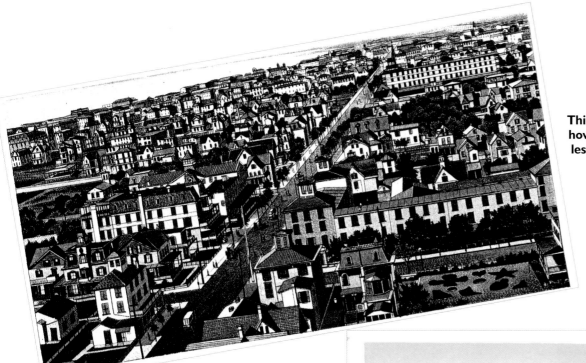

This city view from 1890 shows how much the city had grown in less than forty years.

Atlantic City High School stood at Pacific and Ohio Avenues.

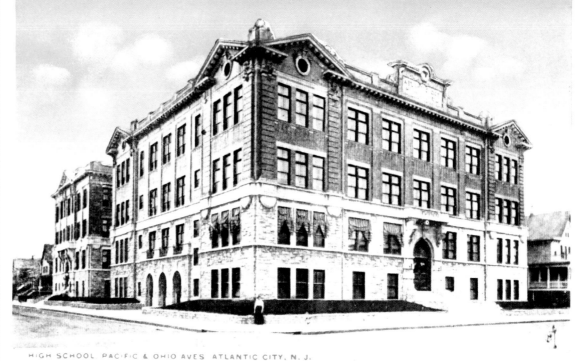

HIGH SCHOOL PACIFIC & OHIO AVES ATLANTIC CITY, N. J.

113

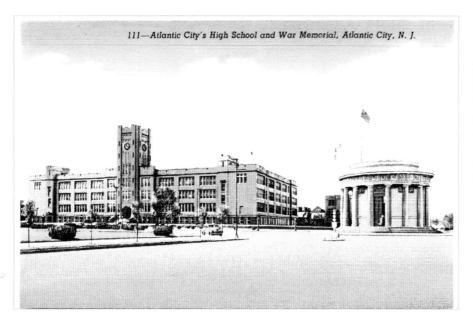

111—Atlantic City's High School and War Memorial, Atlantic City, N. J.

Atlantic City High School, facing the Albany Avenue Circle, opened in 1923. It had an attendance of 2,300 students, and was considered one of the finest schools in New Jersey. Its pipe organ was, "one of the finest in any educational building in America."

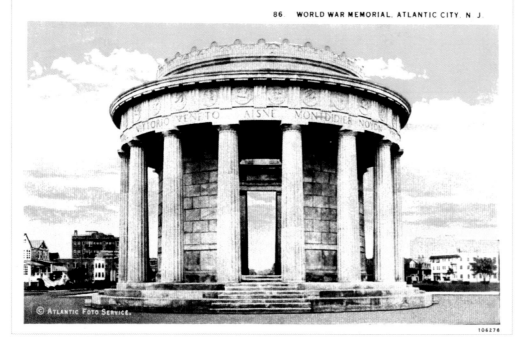

86. WORLD WAR MEMORIAL, ATLANTIC CITY, N. J.

© ATLANTIC FOTO SERVICE.

106276

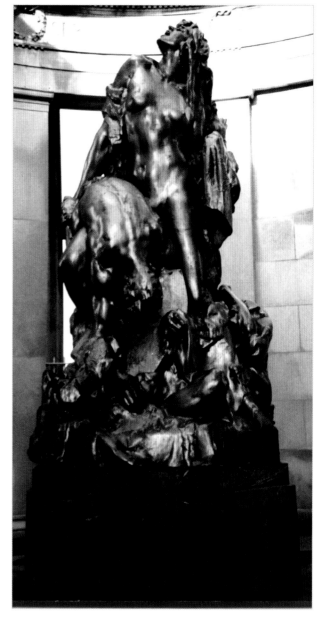

The World War Memorial, across from the High School, was built to commemorate World War I. The inscription inside the monument reads, "This monument was erected in 1922 by the City of Atlantic City in Honor of Those Hero Citizens Who Served in the World War 1917-1918."

In the center of the World War Memorial is a bronze statue by Frederick W. MacMonnies called "Liberty in Distress." The statue was added to the Memorial in 1929.

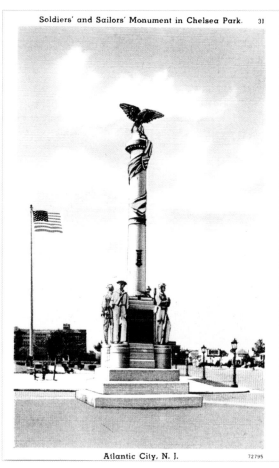

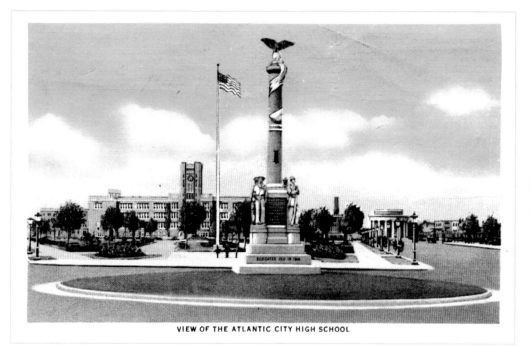

VIEW OF THE ATLANTIC CITY HIGH SCHOOL

This scene shows the high school, the World War Memorial, and the Soldiers' and Sailors' Monument.

The Soldiers' and Sailors' Monument was in Chelsea Park, near the high school. The plaque inside reads, "Erected to the memory of the Soldiers and Sailors of the Civil War, 1861-1865." Inscribed on the bottom of the monument, "Dedicated December 16, 1916."

The All Wars Memorial Building, at 814 Pacific Avenue, was built by the City for use as a headquarters for all veterans' activities. It opened August 18, 1925.

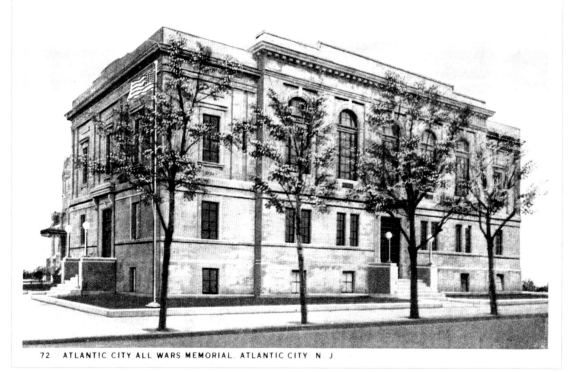

72 ATLANTIC CITY ALL WARS MEMORIAL, ATLANTIC CITY, N. J.

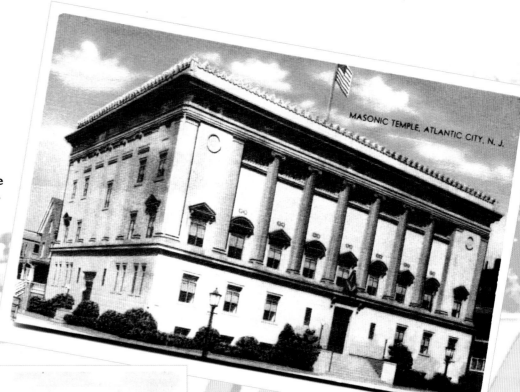

From the back: "The Masonic Temple opposite Albany Avenue Park was erected in 1926. Its cornerstone was transported from the ancient quarry of King Solomon."

Birds Eye View of Chelsea, Atlantic City, N. J.

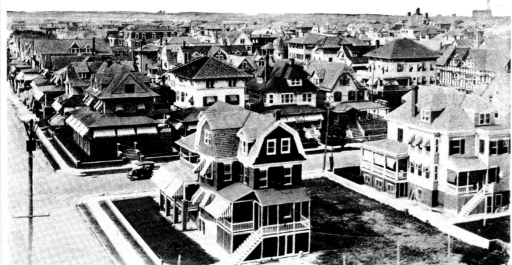

The neighborhood of Chelsea was in the southern end of Atlantic City.

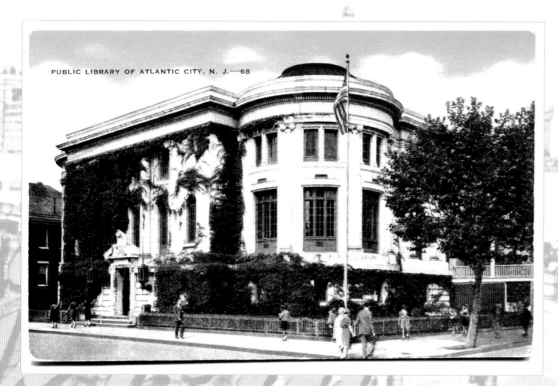

PUBLIC LIBRARY OF ATLANTIC CITY, N. J.—68

The main Public Library was at Illinois and Pacific Avenues. It was a gift to the city from Andrew Carnegie in 1904.

The Young Women's Christian Association, at North Carolina and Pacific Avenues, was built in 1928. From the back: "The Y.W.C.A. has for its purpose improvement of the spiritual, intellectual, social and physical condition of young women."

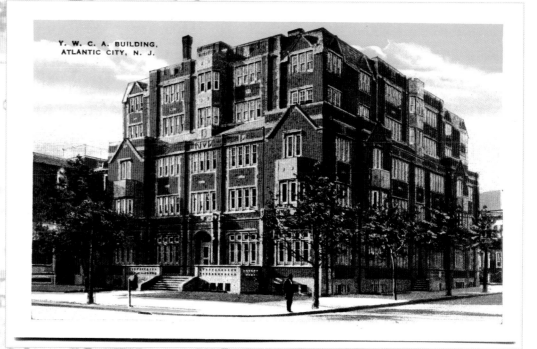

Y. W. C. A. BUILDING, ATLANTIC CITY, N. J.

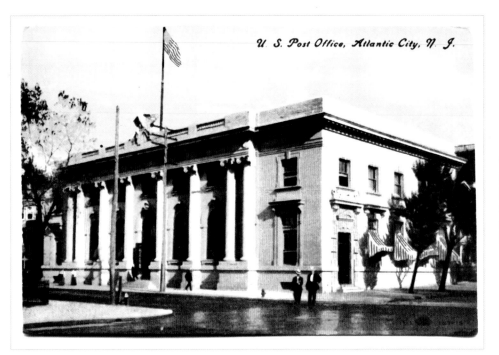

The first building constructed by the United States Post Office Department opened on the southwest corner of Pennsylvania and Pacific Avenues August 13, 1905. Harry Bacharach was postmaster.

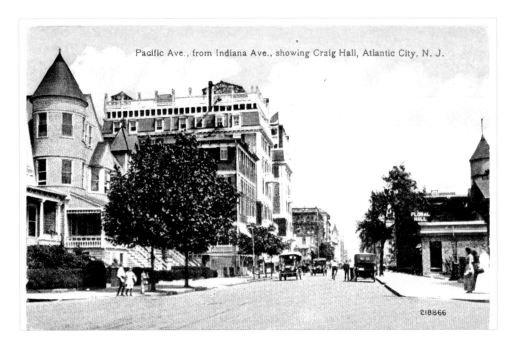

Craig Hall, the building on the left in this view, was torn down in 1936 to make way for a new post office.

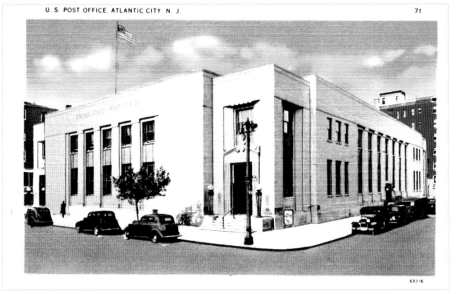

The cornerstone for the new post office, at Illinois and Pacific Avenues, was laid April 4, 1936. The post office opened for use February 22, 1937. Thomas C. Stewart was postmaster.

The Children's Seashore Home was incorporated February 18, 1873 under the direction of Dr. William H. Bennett. The home was established to care for crippled children following the summer of 1872 when a group of Philadelphians rented a cottage to give a vacation at the seashore to a group of invalid Quaker children. It was the first institution of its kind in the country.

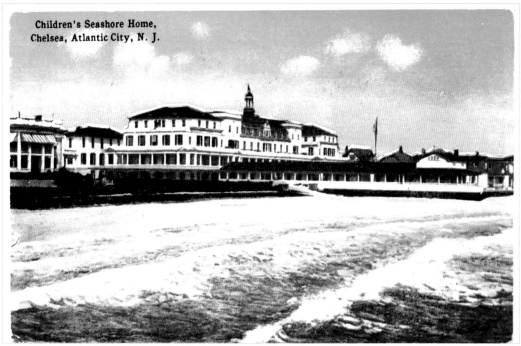

Children's Seashore Home, Chelsea, Atlantic City, N. J.

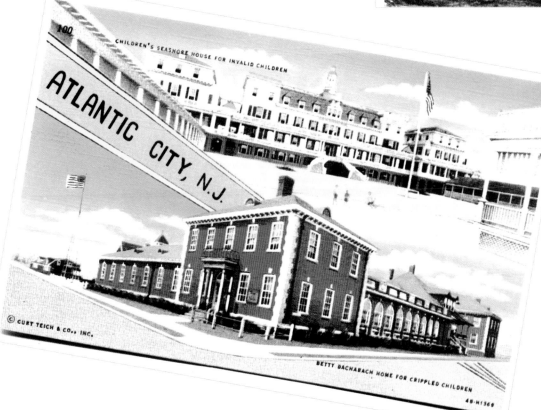

CHILDREN'S SEASHORE HOUSE FOR INVALID CHILDREN

ATLANTIC CITY, N.J.

© CURT TEICH & CO., INC.

BETTY BACHARACH HOME FOR CRIPPLED CHILDREN

The Betty Bacharach Home was established in 1926 by Issac and Harry Bacharach in honor of their mother, who had died earlier that year, "So that they may walk."

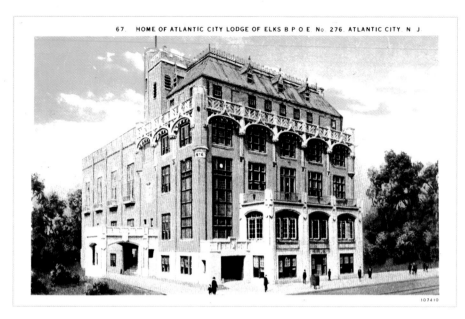

The Atlantic City Lodge of Elks B.P.O.E. #276.

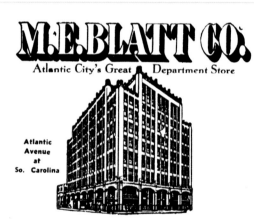

M.E. BLATT CO.

Atlantic City's Great Department Store

Atlantic Avenue at So. Carolina

THE SHOPPING CENTER OF SOUTH JERSEY

STREET FLOOR
Cosmetics, Silverware
Books, Stationery
Notions, Jewelry
Women's Hosiery
Neckwear
Knit Lingerie
Umbrellas, Gloves
Handkerchiefs
Laces and Dress
 Trimmings, Ribbons
Leather Goods, Small
 (Handbags, Belts,
 Jewelry Boxes)
Men's Furnishings
Circulating Library
Electrical Clocks

MEZZANINE
Restaurant and Foods
Gifts, Toys, Candy
Watch Repair
Art Needlework
Luggage

SECOND FLOOR
Silks and Woolens
Yard Goods, Patterns
Bedwear, Blankets
Household and Fancy
 Linens

Boys' Clothing
 (Scout Dept.)
Men's Clothing, Hats
Women's Shoes,
 Children's Shoes
Men's & Boys' Shoes

THIRD FLOOR
Millinery
Jr. Clothing (Evening
 Gowns)
Misses' and Women's
 Dresses
Coats and Suits
Sportswear, Blouses
Furs, Fur Repair
Fur Storage
Bathing Suits

FOURTH FLOOR
Corsets, Lingerie
Housedresses,
 Uniforms, Kimonas
Infants' Layette
Infants' Furnishings
Boys & Girls, Size 1-6
Girls' Clothing
Children's Hosiery

FIFTH FLOOR
Lamps

China and Glassware
House Furnishings
Hoover Cleaners
Paint
Garden Tools

SIXTH FLOOR
Rugs and Linoleum
Draperies and Uphol-
 stery, Slipcovers,
 Venetian Blinds

SEVENTH FLOOR
Furniture
Beach Furniture

EIGHTH FLOOR
Sleep Center
Shoe Repair

**STREET FLOOR,
ANNEX**
Wine & Liquor Store

APPLIANCE STORE
Sinks, Stoves, Refrig-
 erators, Electrical
 Appliances,
 Television and
 Radios

CALL 4-1111 FOR PERSONAL SHOPPING SERVICE

This advertisement for M. E. Blatt Co., "Atlantic City's Great Department Store," shows the many wares they offered.

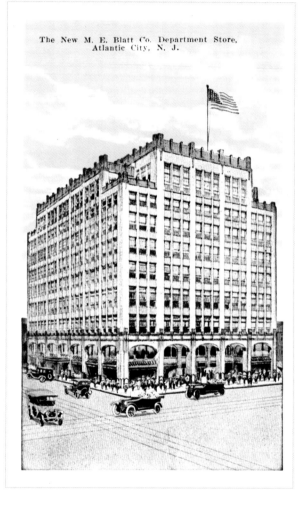

The New M. E. Blatt Co. Department Store, Atlantic City, N. J.

The M. E. Blatt Company Department Store was on Atlantic Avenue at South Carolina Avenue. It was the biggest department store in Atlantic County at the time.

The Hygeia Swimming Pool, on the Boardwalk at Rhode Island Avenue, hosted the first-ever championship lifeguard swim competition in 1913. Dr. Charles L. Bossert, chief of the Atlantic City Beach Patrol, organized the event. The Ocean City lifeguards won the competition.

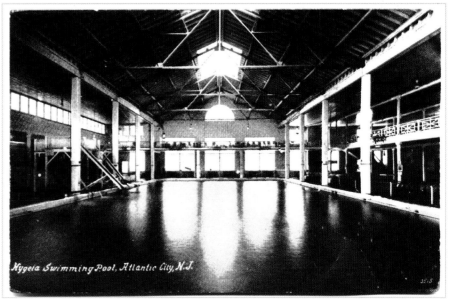

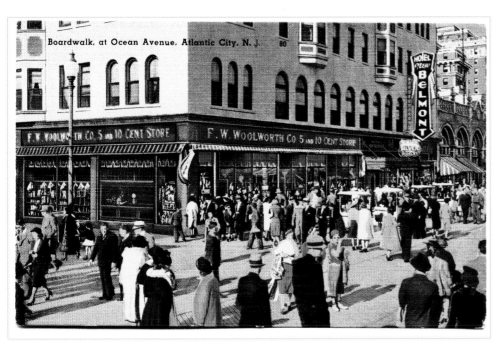

The F.W. Woolworth Co. 5 and 10 Cent Store, on the Boardwalk at Ocean Avenue, was a special kind of store! Because of the competition they had from the amusements surrounding them on the Boardwalk, they featured puppet shows, ragtime bands, "authentic" saltwater taffy, and other enticements to bring in customers.

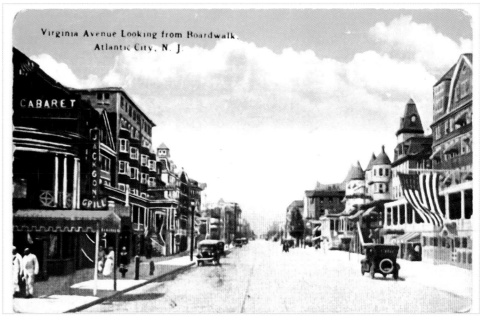

This city view is of Virginia Avenue looking from the Boardwalk.

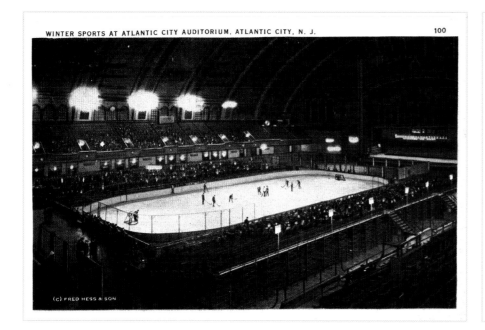

WINTER SPORTS AT ATLANTIC CITY AUDITORIUM, ATLANTIC CITY, N. J. 100

(C) FRED HESS & SON

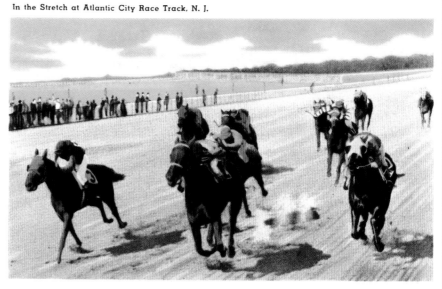

In the Stretch at Atlantic City Race Track, N. J.

The Atlantic City Seagulls hockey team began playing at the Atlantic City Convention Hall in 1930.

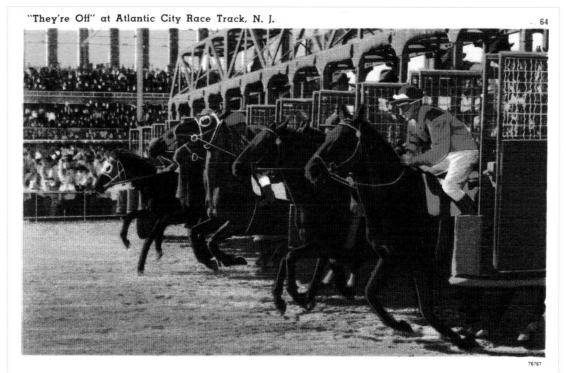

"They're Off" at Atlantic City Race Track, N. J. 64

76767

From the back: "Make Your Summer Vacation a Long One ...Stay for Racing... at the Atlantic City Race Track!"

Opening day at the Atlantic City Race Track was July 22, 1946.

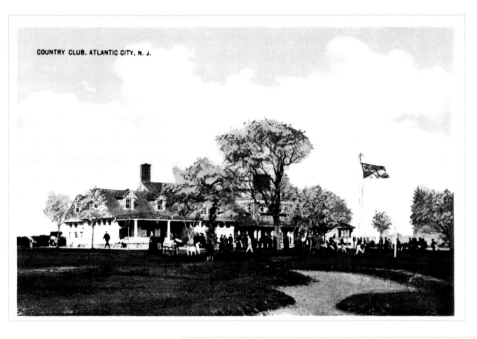

The Atlantic City Country Club opened in 1897. It became one of the finest golf courses in the country.

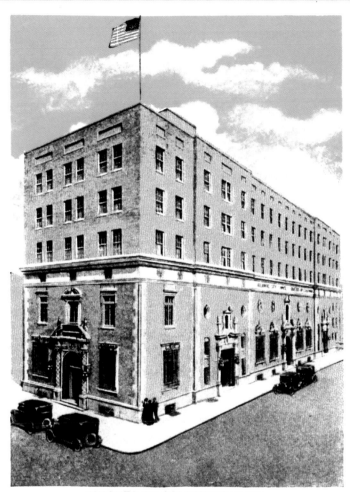

KNIGHTS OF COLUMBUS CLUB

The Knights of Columbus Club.

Rodef Sholem Synagogue, at Arkansas and Pacific Avenues, was dedicated September 10, 1915. It was the first orthodox synagogue on Absecon Island.

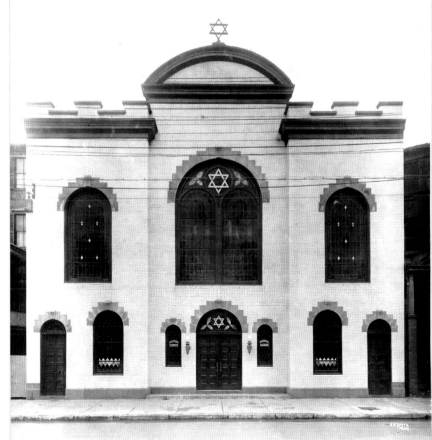

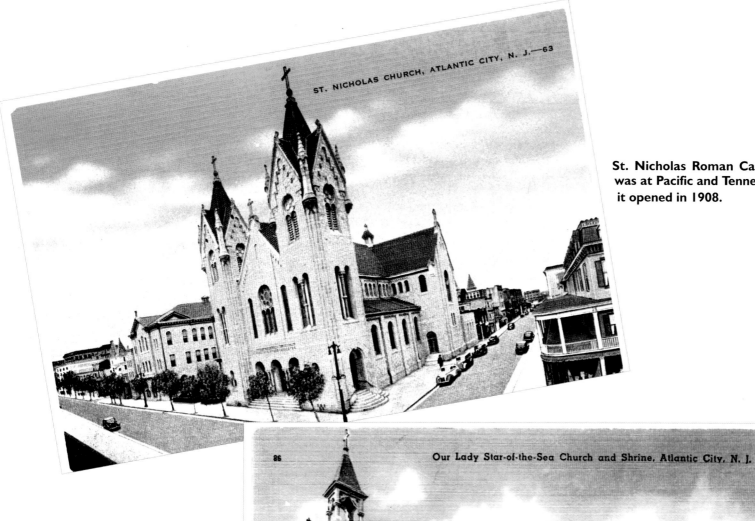

ST. NICHOLAS CHURCH, ATLANTIC CITY, N. J.—63

Our Lady Star-of-the-Sea Church and Shrine, Atlantic City, N. J.

St. Nicholas Roman Catholic Church was at Pacific and Tennessee Avenues; it opened in 1908.

Our Lady Star-of-the-Sea Church was at California and Atlantic Avenues. It was built in 1894.

St. James Episcopal Church was at Pacific and North Carolina Avenues.

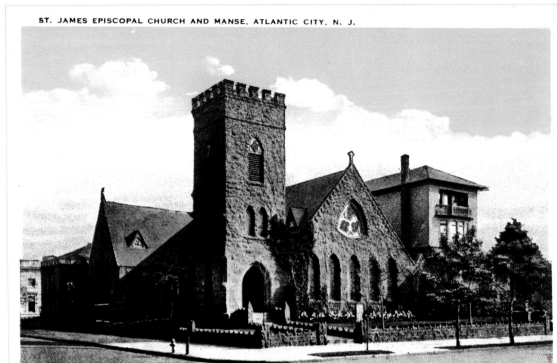

ST. JAMES EPISCOPAL CHURCH AND MANSE, ATLANTIC CITY, N. J.

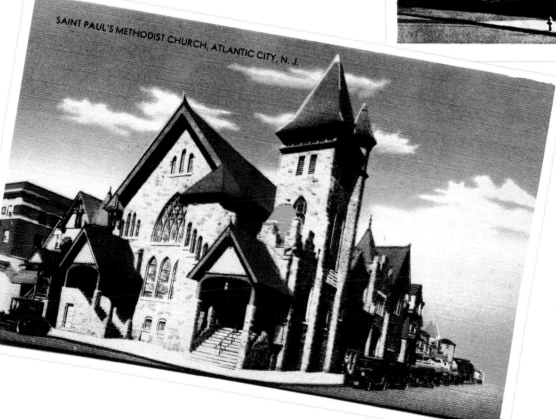

SAINT PAUL'S METHODIST CHURCH, ATLANTIC CITY, N. J.

St. Paul's Methodist Church, at Ohio and Pacific Avenues, opened in 1898.

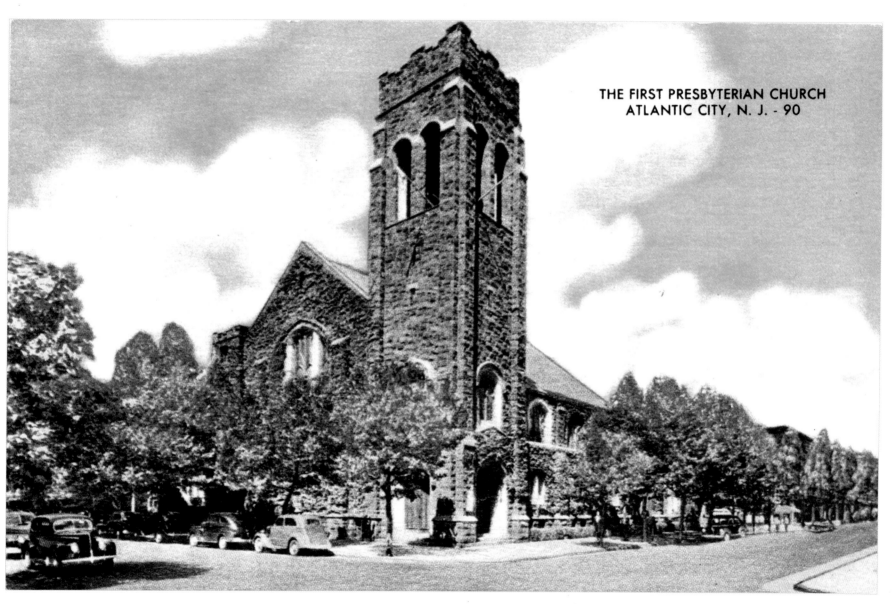

THE FIRST PRESBYTERIAN CHURCH
ATLANTIC CITY, N. J. - 90

The First Presbyterian Church, at Pacific and Pennsylvania Avenues, was founded in 1856.
It is an example of English Norman architecture.

Bibliography

Butler, Frank. *Book of the Boardwalk*. Atlantic City, New Jersey: Haines and Co., 1952.

Davis, Ed. *Atlantic City Diary, A Century of Memories*. Atlantic City, New Jersey: Atlantic City News Agency, 1989.

Field, Van R. and Galluzzo, John J. *New Jersey Coast Guard Stations and Rumrunners*. Charleston, South Carolina: Arcadia Publishing, 2004.

Funnell, Charles E. *By the Beautiful Sea: The Rise and High Times of That Great American Resort, Atlantic City*. New Brunswick, New Jersey: Rutgers University Press, 1983.

Heston, Alfred M. *Absegami: Annals of Eyren Haven and Atlantic City, 1609 to 1904*. Atlantic City, New Jersey: self-published, 1904.

Kent, Bill, Ruffolo, Robert E. Jr., and Dobbins, Lauralee. *Atlantic City, America's Playground*. Encitis, California: Heritage Media, 1998.

Levi, Vicki Gold and Eisenberg, Lee. *Atlantic City: 125 Years of Ocean Madness*. Berkeley, California: Ten Speed Press, 1994.

Lurie, Maxine N. and Mappen, Marc. *Encyclopedia of New Jersey*. New Brunswick, New Jersey: Rutgers University Press, 2004.

McMahon, William. *So Young…So Gay, Story of the Boardwalk 1870-1970*. Atlantic City, New Jersey: Atlantic City Press, 1970.

Miller, Fred. *Ocean City: America's Greatest Family Resort*. Charleston, South Carolina: Arcadia Publishing, 2003,
Ocean City: 1950-1980. Charleston, South Carolina: Arcadia Publishing, 2006.

Miller, Susan. *New Jersey's Southern Shore, An Illustrated History from Brigantine to Cape May Point*. Atglen, Pennsylvania: Schiffer Publishing Ltd., 2008.

Shanks, Ralph, York, Wick, and Shanks, Lisa Woo, editor. *The U.S. Lifesaving Service-Heroes, Rescues and Architecture of the Early Coast Guard*. Petaluma, California: Costano Books, 1996.

Index